OREGON GOLF

THE OREGON COAST ◆ SOUTHERN OREGON

PORTLAND & ENVIRONS ◆ CENTRAL OREGON

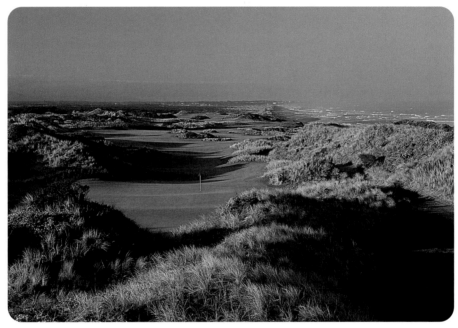

Text by PAUL LINNMAN

Photography by RICK SCHAFER

◆

FOREWORD BY PETER JACOBSEN

GRAPHIC ARTS CENTER PUBLISHING®

Jim —
Fairways and
greens forever!
Enjoy
Paul Linnman

For Vicki, the greatest partner ever, in golf and in life.
—Paul

For my friends, who've helped teach me the joy of playing golf.
—Rick

We would like to thank Jim Gibbons of the Oregon Golf Association for his help and support, as well as all the superintendents, general managers, and groundskeepers that help keep Oregon's golf courses among the finest in the world.

Library of Congress Cataloging-in-Publication Data
 Linnman, Paul, 1947–
 Oregon golf / text by Paul Linnman ; photography by Rick Schafer ; foreword by Peter Jacobsen.
 p. cm.
 Includes index.
 ISBN 1-55868-474-3 (hard : alk. paper)
 1. Golf—Oregon Guidebooks. 2. Golf courses—Oregon Guidebooks. 3. Oregon Guidebooks.
 I. Title.
 GV982.074L56 1999
 796.352'06'8795—dc21 99-25224
 CIP

President: Charles M. Hopkins
Editorial Staff: Douglas A. Pfeiffer, Ellen Harkins Wheat, Timothy W. Frew,
 Jean Andrews, Alicia Paulson, Deborah J. Loop, Joanna M. Goebel
Production Staff: Richard L. Owsiany, Lauren Taylor, Heather Hopkins
Design/Typography: Elizabeth Watson
Digital Color by Color Technology,
 a division of CTI Group
Paper by Spicers Paper
Printed by Graphic Arts Center, a Mail-Well Subsidiary
Bound by Lincoln & Allen Company

Photos in front matter and back matter.
Page 1: Developed more than a century after the first golf course in the state was opened on the North Coast, Bandon Dunes, on the South Coast, is a recent, much-celebrated arrival to Oregon golf; Pages 2-3: The lake at historic Portland Golf Club, fed by Fanno Creek, wraps around the 7th green and 11th tee. PGA Tour players first discovered the beauty of golf in the Pacific Northwest when the inaugural Portland Open was played here in 1944; Pages 4-5: Senior players in Portland avoid weekend crowds by playing dawn rounds on weekdays at the city's excellent municipal courses. Rose City, in Southeast Portland, is one of the most popular sunrise venues. Tee times in summer begin as early as 4:52 am. Page 96: Dawn at Portland's Pumpkin Ridge: let the game begin!

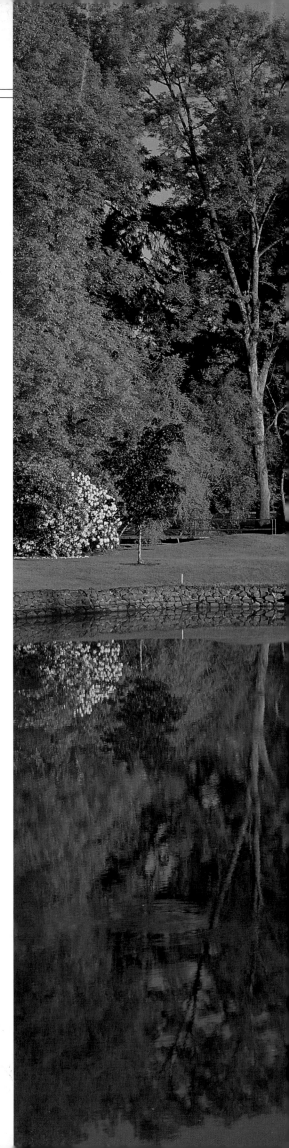

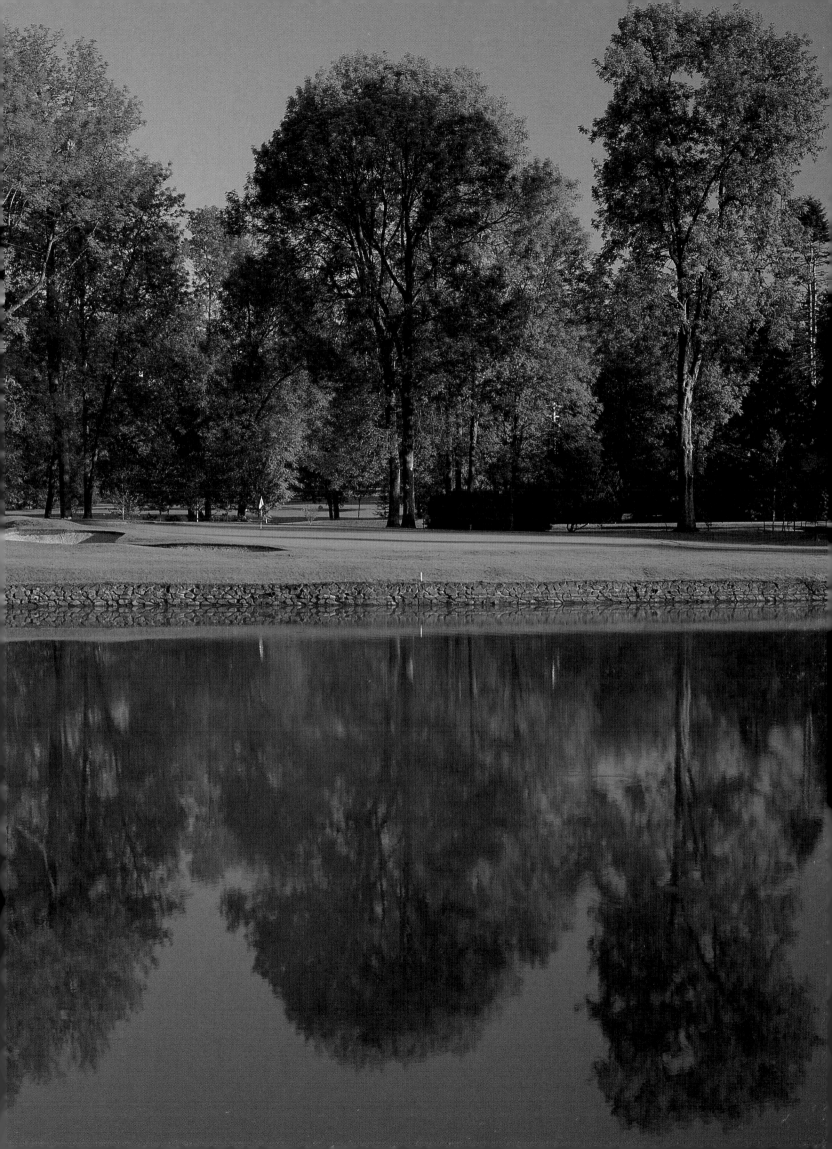

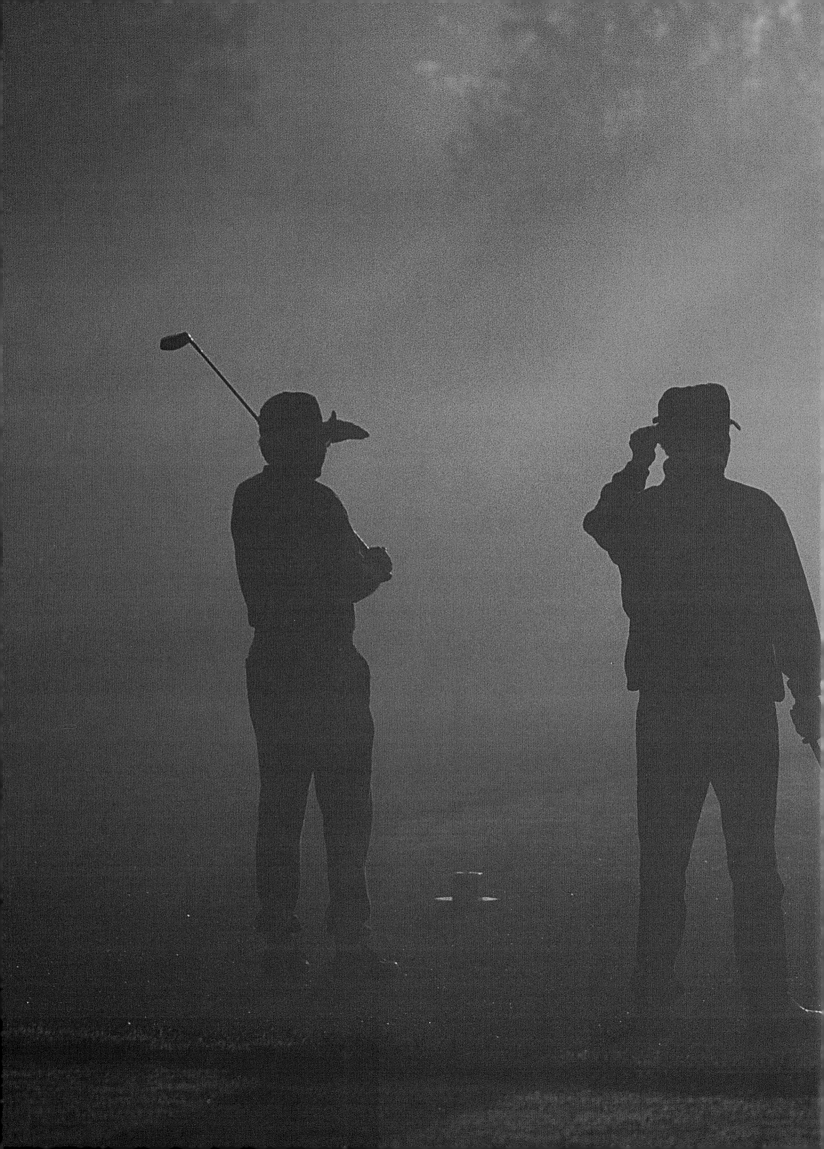

ONTENTS

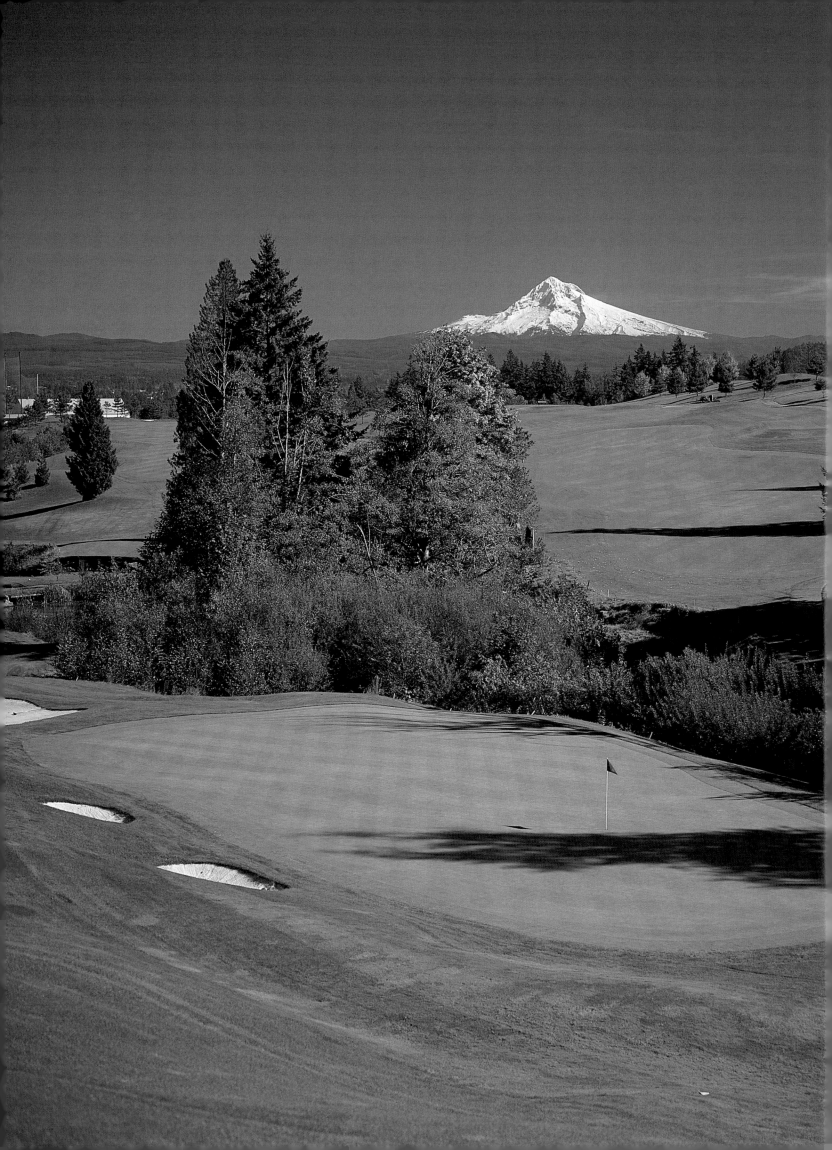

FOREWORD

PETER JACOBSEN

When I first joined the PGA Tour, in 1976, I was in Dallas, Texas, to play in the GTE Byron Nelson Classic. When I met Mr. Nelson, he asked where I was from.

"Portland, Oregon," I responded proudly.

"You can't play the tour from Portland," Byron said. "It's too far away."

"Just watch me," I answered.

I probably sounded a little bold for my age, but it turns out I was right. More than two decades later, after playing

◄◄ Mt. Hood, one of the most climbed mountains in the world, is a familiar sentinel for many Oregon courses, including the semiprivate Persimmon Country Club, located in Gresham. The deep, wooded ravine that runs in front of both the 9th and 18th greens is, in a word, jail.

◄ Ready for another day's work, only golf's flags serve exclusively as targets.

▲ At the Oregon Golf Club, near West Linn, the back tees are properly dedicated to the state's best-known professional player and the course's co-designer, Peter Jacobsen.

golf around the world, I'm still convinced there's no better place than Portland to live—or play golf.

I was introduced to the game at Portland's Waverly Golf and Country Club, at the age of 12, as a caddy for my dad and his friends. I quickly learned that I was happiest when I was on the golf course.

In my youth, I played mostly at Portland's public courses—Eastmoreland, Progress Downs, and Rose City—courses I loved then and still love today. When I played on the Lincoln High School team we'd go across town to play Glendoveer, another public course, and during those times it felt like I was on a major trip. Traveling downstate to Rogue Valley in southern Oregon for a junior event, I might as well have been going to France.

After learning to play at so many great Oregon courses, I was able to win the Portland and then the Oregon high school championships. More important, I developed a passion for golf that has never diminished.

Summers, my family went to the Oregon Coast to golf. I can still remember my dad waking me and my brothers and sister early to play Astoria Golf and Country Club. It was there that I began to learn shot-making, while playing over the dunes in the wind and rain. We'd play twenty-seven or thirty-six holes a day in all conditions.

When I went to the University of Oregon in the 1970s, our golf team played Eugene Country Club, Shadow Hills, Emerald Valley, and Tokatee. I can't imagine four better courses a college kid could play. My future wife, Jan, was on the women's team, and we'd often sneak away afternoons to play Tokatee up in the Cascade Mountains, with a picnic between nines. Playing such a variety of courses ultimately convinced me that I could make a living in the game of golf from my home in Portland.

I've said before that one of my only regrets about being a professional and playing great courses all over the world is that I seldom have enough time to play the beautiful courses in my own backyard. I don't meet many golfers who understand that for variety and quality—Oregon's courses are also among the best maintained anywhere—you can't beat my home state. But I've been able to bring the best golfers in the world back to Oregon every year to play our charity event, the Fred Meyer Challenge,

O R E G O N G O L F

Steep terrain is a hallmark of the Oregon Golf Club. The 12th green may appear at eye level from the middle tee, but it requires an adventurous walk—a thrilling ride for those who favor carts—down and up in order to reach it. Club selection can be even more exciting.

and I've also found that wherever I go, I can find a place that reminds me of what it's like to play golf in Oregon.

When I play Augusta, I'm really seeing Oregon Golf Club in Portland. When the tour swings through the deserts of Arizona or California, I could be at any of Central Oregon's excellent courses. Playing in Scotland, I feel like I'm not far away from Astoria or Gearhart or Seaside or Agate Beach or Sandpines. Merion in Pennsylvania brings to mind Waverly or Portland Golf Clubs. And playing Riveria in Los Angeles is akin to playing Eugene Country Club.

And while I now can play anywhere in the world, I look forward to a time when I can come home to Oregon and go out for eighteen holes with my friends. We have a house at the coast, and the thought of getting up every day and playing twenty-seven holes at, say, Salishan—without having to catch a flight to the next tour event—sounds like heaven.

The distinctive Oregon golf experience is described vividly in the following essay photographed and written by a couple of serious Oregon journalists and golfers, Rick Schafer and Paul Linnman. Oregon golf may mean different things to different golfers—that's the beauty of our game. This book captures its many varieties in enticing detail.

As a matter of fact, I'm going to give a copy of the book to Byron Nelson.

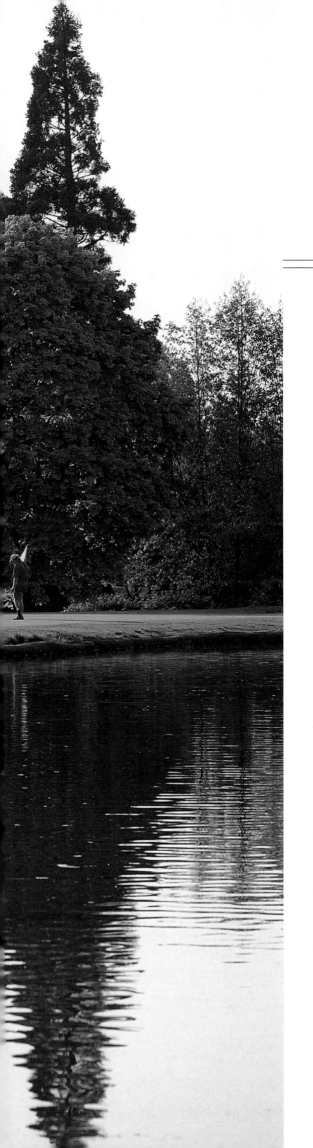

PLAY AWAY

INTRODUCTION

If you've played any golf at all, you've likely encountered the golfer who says, "I really don't care how I score; I just come out to enjoy the whole experience—the course, the fresh air, the beautiful surroundings." Such people are inveterate liars, of course—no one actually enjoys playing poorly—but the lie is more believable in Oregon than anywhere else. The golf courses are so striking and varied in this special corner of the country, that it's actually conceivable one might want to play them just to walk through such magnificent country.

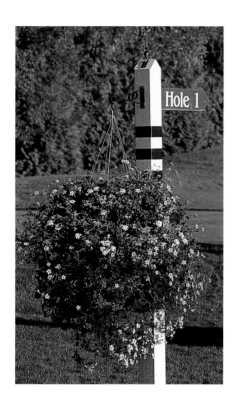

◄◄ The 17th green at Portland's Eastmoreland Golf Course, perennially rated among America's best public courses, is surrounded on two sides by Crystal Springs Lake, home to a variety of waterfowl and golf balls.

◄ Vanity, thy name is golf. Career best scores give some Oregonians license to brag.

▲ One of the leading nursery states in the nation finds it quite appropriate to add hanging flower baskets to the natural beauty of a golf layout, here at Langdon Farms Golf Course, in Aurora.

If you drive ninety minutes from Portland you'll find sweltering deserts, sparkling lakes, grand mountains, deep forests, and a vast ocean. So, too, can you find golf courses in these vastly varied contexts throughout the state. There are courses where walking is required because carts aren't allowed (Bandon Dunes in Bandon), holes that require a stroll through a historic railcar between tee and green (Lost Tracks in Bend), and a layout that was reduced from full-size to executive length in order to protect an endangered species of butterfly (The Highlands in Gearhart, which ended up adopting the butterfly as its logo). Many Oregon courses were working cattle ranches at the turn of the century; one is located on an Indian reservation where players may still see wild mustangs running over sage-covered hills above the fairways (Kah-Nee-Ta in Warm Springs). Yet another course features short stone walls such as those found on European World War II battlefields, and which American soldiers used for training before shipping out for the front (Stoneridge in Medford).

When the fabled Ryder Cup matches were resumed in 1947, after being suspended for the duration of World War II, the first was played at Portland Golf Club. Meadow Lakes, in Prineville, was built as part of its town's wastewater treatment site, and Heron Lakes, in Portland, agreeably allows groups of ornithologists to cross its fairways and observe nesting blue herons.

In addition to enjoying the rare privilege of being able to tee it up either in the desert, on mountain ridges, or on coastal links, Oregonians have grown accustomed to having their favorite venues listed by national experts as among the very best new, resort, public, private, and most affordable golf courses in America. Such listings are never news to locals; just early warning that more vacationing golfers are on the way.

"Golf here is just not typical of other places," says Jim Gibbons, who heads up the Oregon Golf Association, one of only two state organizations in the country that has constructed a course for its own members (Tukwila in Woodburn). "For instance, we don't really have any courses requiring that you ride a cart. There's still a friendly, encouraging atmosphere—even though we range from the mom-and-pop courses up

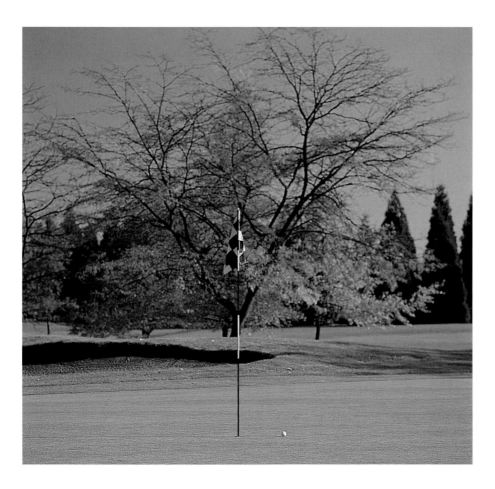

◄ *At many locales in a state known for its forests and timber industry, the deep green of conifers is often contrasted by seasonal color, as it is here at Heron Lakes in Portland. Two municipal courses—the Greenback and the Great Blue, both named for resident herons and designed by Robert Trent Jones—are among the most heavily played in the metro area. They are also highly ranked among public courses in the United States.*

through the major resorts. The cost is still reasonable, and golf has just evolved to be the way people want it."

Gibbons has it right. I grew up on and still enjoy the fine public courses of Oregon's largest city, Portland, and have traveled the state to play not only its most magnificent courses but also its ordinary nine-holers. I love them all. That makes me no more an expert at Oregon golf than the next guy waiting with his foursome for dawn to break at Eastmoreland or Rose City in Portland.

My wife, Vicki, and I recently spent a summer revisiting favorite old courses, which seem always to improve with age, and discovering sparkling new courses that made us feel there could be no more pleasant place to play, only to have the same feeling at the very next stop. What follows are some of the highlights of our summer odyssey, which confirmed what we'd long suspected. The most glorious works of God and man can be found on golf courses. In Oregon.

▼ *Oregon players are well aware of golf's newest hazard—as found at the OGA Members Course at Tukwila, in Woodburn. Signage may use different approaches, but the message is always the same: your golf ball may enter, but you may not!*

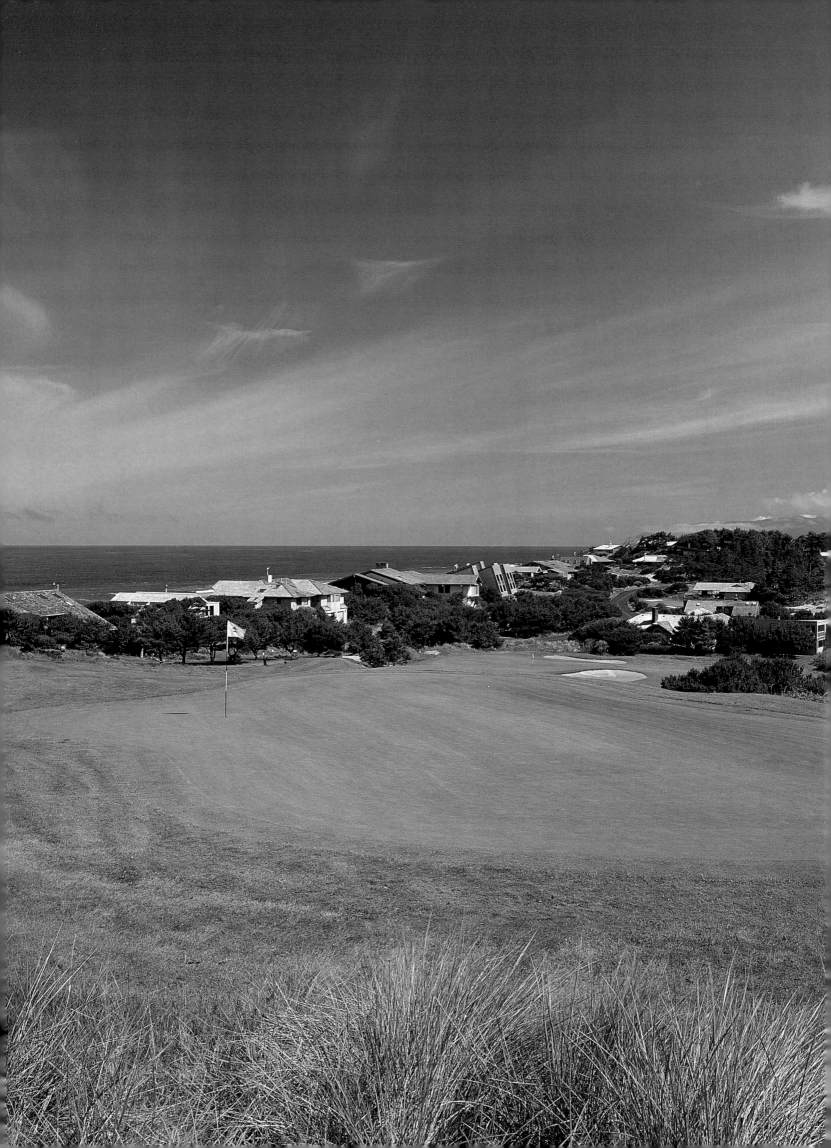

WATER ON THE LEFT

THE OREGON COAST

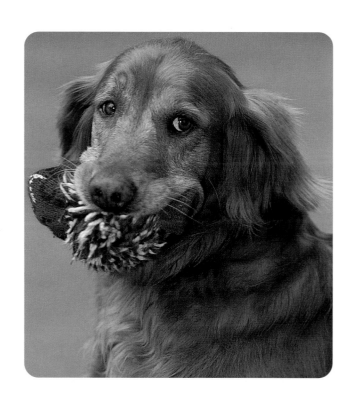

*W*e begin where golf began in Oregon, on the North Coast. It was here that Gearhart Golf Links opened in 1892, four or five years after golf was introduced in the United States on the East Coast. While there is considerable debate regarding how golf spread through the nation, Gearhart is undoubtedly the oldest course in Oregon and arguably the oldest in the West.

Thousands flock to Gearhart each year for its historic heritage, and also because it is a true links course and a good test of golf.

◄◄ Salishan Golf Links off Highway 101 in Gleneden Beach is one of the most sought-out courses in Oregon. Its testing and very well maintained holes—"fair but not easy" by one regular's account—along with distinctive sod-faced bunkers and tricky approaches to quick greens, require golfers to use every club in the bag. Visitors are well advised to follow the admonition over the pro shop door (the message actually first posted in Troon, Scotland): As Much by Skill as by Strength.

◄ Brodie, usually found lounging about the pro shop with a perfect grip on his favorite headcover, is the official greeter for players and their dogs at Agate Beach Golf Course, in Newport.

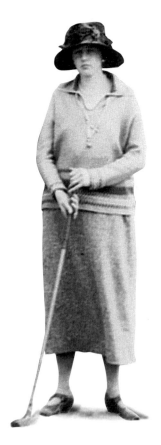

For more than a century, Gearhart set itself apart from every other venue by steadfastly refusing to water its fairways, with the exception of the first and tenth holes. Most of the year it looked like any other course, but in summer the fairways turned a delicate shade of brown, playing hard and fast. "We got in an order of new scorecards a while back," says professional Jim Smith, "and the printer had touched up the photograph of the golf course so it looked a bright green. The owners sent them back and told him never to do that again."

A significant change at Gearhart took place in 1998, in the aftermath of a devastating fire that destroyed a restaurant and lounge called the Sandtrap, which had operated for years next to the practice putting green. Afterward, the course's owners decided to use the blaze as an opportunity for modernization, so they added fairway bunkers, lengthened some holes, using grassy mounds to better define greens and—gasp!—irrigated the fairways. The time had finally arrived for the greening of Gearhart. I, for one, will always remember the course as brown, but those who know it best say its essential qualities have not been compromised. "This course is [still] the closest thing to Scottish golf that I have found," says Smith.

Another variety of links golf can be found a few miles to the north at Astoria Golf and Country Club. Astoria's 6,494 yards traverse uncommonly high dunes about a mile east of the Pacific Ocean, with many fairways cutting between great ridges to create deep channels of play. Miss the fairway with a tee ball and you may find yourself one steep ravine away—or maybe even two—from your target line. These great fairway valleys are a sight to see, incredibly fun to play and, ironically, may favor the short hitter.

"I think I handle the course better now than when I used to hit the ball quite a ways," says Si Wentworth, an eighty-three-year-old retired J.C. Penney's manager and Astoria member. "Now I'm not up on those ridges, and I'm not climbing up one side and down another."

On a Sunday morning, we played in the monthly Breakfast Club match with Jeff Leinassar, a local dentist and former Astoria champion

O R E G O N G O L F

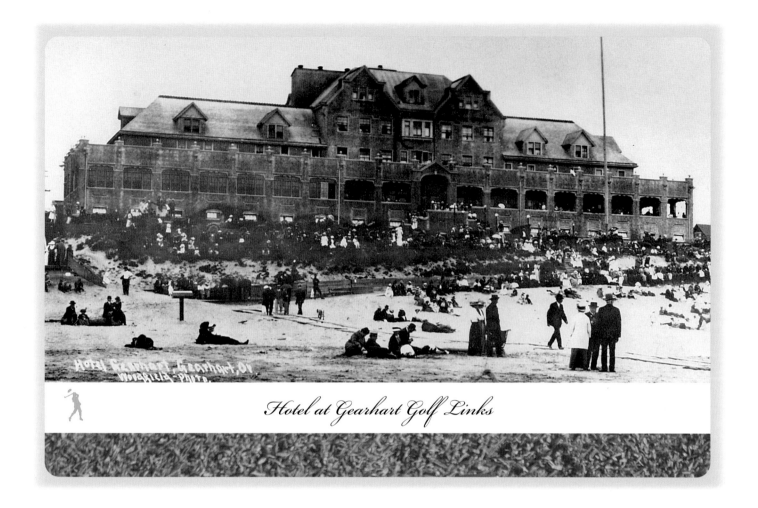

Hotel at Gearhart Golf Links

who only weeks later would win his third Coast Invitational. Also in our group was Scott Peterson, one of many members from Portland who think nothing of driving 160 miles round-trip for a Sunday round. "Weather's actually one reason," says Peterson, "it can be raining in Portland and not raining here. And this course, well it's just amazing."

Leinassar understands completely. "Every hole is fun; each one is a challenge," he says. "You know you're not just playing another course like the one next door."

The deep dune fairways notwithstanding, our group played well here, only to have the locals tell us we must return to "the St. Andrews of the Pacific," as it has been called for more than half a century, on a day when the wind is blowing. Then, we were told, things really get exciting. It is a private course but visits by nonmembers can be arranged. (We include private clubs in our review because they are an important part of Oregon

An early-day North Coast landmark, long since destroyed by fire and replaced with condominiums, the Gearhart Hotel was built across North Marion street from the Gearhart Golf Course in 1913, more than twenty years after the golf links began attracting residents and summer visitors alike.

golf and in some ways can represent the game of golf at its best. Perhaps the biggest single challenge facing the average golfer is to figure out a way to get on them. With the possible exception of Augusta National in Georgia, or Muirfield in Scotland, the serious player can find a way to play anywhere.)

Also on the North Coast, the public Seaside Golf Course is an appealing stop for golfers and history buffs alike. Located south of Gearhart and Astoria, between the town of Seaside and Highway 101, the straight-forward design of the course makes it playable for the beginner or infrequent golfer. It is flat, doesn't have a single sand trap, and lends itself nicely to leisurely summer vacation rounds.

Seaside is built on land that was once home to the Clatsop Indians. Centuries later it became the resort area of choice for the Portland elite of the 1920s and '30s. In the summer, men wearing suits and high collars commuted to Seaside on weekends by train to join their vacationing families. With that history, some golf venues in the region have an East Coast feel, and many, like Seaside, display intriguing old photos.

Traveling south, there are a variety of short, nine-hole courses that mirror the personalities of their coastal communities. Notable are Manzanita, popular among vacationers from Portland despite its challenging par-3 holes, and the Hawk Creek and Neskowin courses, which are across Highway 101 from each other near Neskowin.

I fondly recall playing Neskowin's 7th hole as a youngster while learning the game from my dad. An extremely elevated tee requires a steep hike up, and then there's a touch shot 50 feet down, with a carry of some 125 yards, to the little green below. Hit it long and there's no problem, but tap it too soft and your ball falls into Butte Creek, which runs in front of the green. Happily, the course's new owner, Tom Clark, has brought the tee back after years of disuse and neglect. Playing the "cliff hole" became the highlight of our one-week vacation at Neskowin.

The other good news about Neskowin is that, like Seaside, its high water table allows no sand traps; the bad news is that the course is largely underwater in winter. Jeff Shelley, in his excellent guide, *Golf Courses of*

the Pacific Northwest, claims that windsurfers have actually been seen sailing across the course in those wet months.

Almost all Oregon coast courses are home to a variety of wildlife. It's not uncommon to share fairways with deer, elk, rabbits, and an occasional coyote, as well as beavers, otters, swans, egrets, herons, ducks, and more. Oregonians are quite used to this. I've seen golfers on the practice range at Black Butte, in Central Oregon, simply turn slightly to redirect their shots away from a group of deer grazing near the 150-yard marker, apparently unfazed by the golf balls falling nearby. But be aware: in Oregon, critters can come into play.

On a visit to the incomparable Salishan resort on the Central Coast, my oldest son, Darin, and I were playing the second hole when his approach shot was squirreled away by . . . a squirrel. We watched in

Oregon courses, such as Hawk Creek in Neskowin, generally remain open for play year-round, come morning dew, fog, afternoon downpours—everything but high water, which is a frequent visitor to both Hawk Creek and the nearby Neskowin Beach.

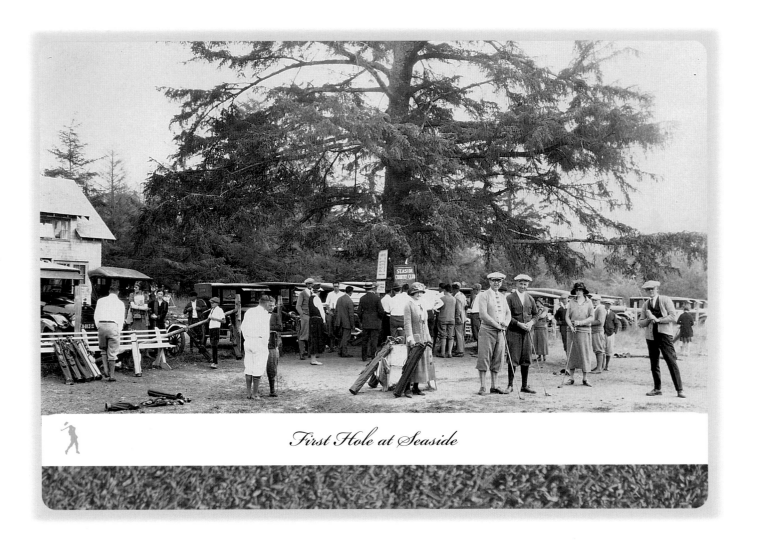

First Hole at Seaside

Seaside was the place to vacation for Portlanders in the 1920s, who, with the Great War behind them, were eager for the recreation that golf provided. But husbands who arrived by train for weekends of relaxation most certainly did not head off to the course alone. The first tee shows men and women, dressed to the nines, ready to step up and hit.

amazement as the small animal "chested" the ball with his paws and ran with surprising speed to the nearby woods, where we imagined there was a sizeable cache of Titleists and Maxflis.

"Free drop where you think the ball was," explained Grant Rogers, Salishan's head pro, who was well aware of the larcenous squirrel. Rogers is the only "master" professional in Oregon—which means he's actually completed thesis work in golf—and a storyteller with whom it's as much fun to converse as play golf.

On our last visit, Grant told us of a friend (we'll call him Barry) who has a famously bad temper. After watching Barry blow his top on the links countless times, Grant decided to take him skiing. Things were going well until another skier, riding the chairlift, shouted down some insults about Barry's less than proficient style, whereupon the new skier began

True Links

We finally made it to golf's home, the Pickle Man and me. Neither I nor Rick Steinfeld, a purveyor of dills and gherkins and my partner for scores of dawn rounds on the links course at Heron Lakes, could believe we were actually at St. Andrews!

We arrived at this hallowed ground just in time to putt a little before the sun went down. Before long, we admitted to one another that the practice green was not in very good condition. Much like the adjacent Old Course itself, it was bumpy and brown and a far cry from the lush, manicured courses we had grown accustomed to in Oregon. In fact, before our odyssey to golf's homeland ended, our view of golf courses in general would be changed forever.

The greatest game got its start over windblown sand dunes, mounds of beach grass, sandy bunkers created by sheep seeking shelter, and on hard, brown ground. The average Scot would be appalled by the highly conditioned golf courses of America, but it took a trip like this for us to understand why.

The word "links" may be the most misused, misunderstood term in golf. Its origin is variously given to Scottish golf courses built on ground that "linked" arable land to the sea, or to the fact that, from the start, golf holes were "linked" together. The *Historical Dictionary of Golfing Terms* cites the Old Scottish "lynkis," which refers to ridges and rough, open ground. Webster's goes with both the British-preferred "ridge of land" or "stretch of rising ground," *and* the Scottish-preferred "undulating land built along a coastline." Some golf purists insist that only courses constructed on alluvial

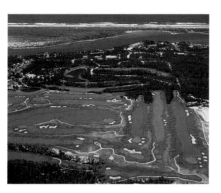

Sandpines Golf Resort, in Florence.

soil—soil left on sand dunes by rivers flowing to the sea—can qualify as links courses. But that description would disqualify the best-known links course in the United States, Pebble Beach, which is built high on a cliff. Finally, no less an authority than British professional Nick Faldo, a links course expert, concludes that it's actually two conditions, wind and natural terrain, that make a links course, and that no genuine links can be found outside of the British Isles.

So how can golf marketers in Oregon advertise links courses that are located in inland valleys or even in the Cascade mountains? The answer is simply that these places are created to be links*like*—duplicating as closely as possible the conditions of the original Scottish coastal courses. For my money, the places that come the closest are Bandon Dunes, Heron Lakes' Great Blue course, and the Cupp Course at the Reserve. A second-tier group might include Sandpines, Salishan, Ocean Dunes, Gearhart, and Astoria Golf Club. Of course, all of the above are too green when compared to Scottish courses, but this is Oregon, after all. It rains thirty-six inches a year *and* we irrigate!

Links courses in Scotland were created by simple folk who barely cleared away enough space to tee it up. By that standard, some of our state's most natural, least-maintained courses may be our true links. The Pickle Man and I now believe that you might find the real St. Andrews of Oregon at any pristine place that offers a simple, straightforward playing field.

After visiting Scotland, we can love them all. Especially the bumpy, brown ones.

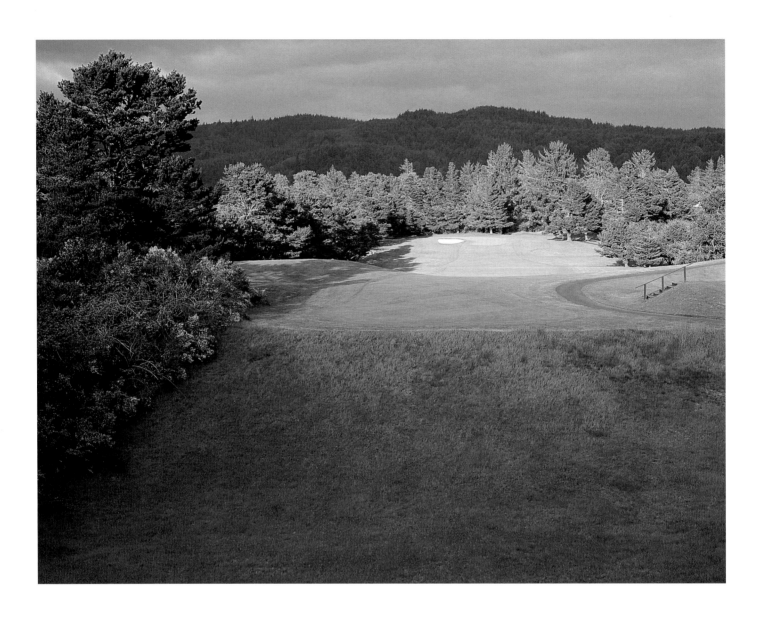

When Astoria Country Club opened in 1924, golfers in the lower Columbia River region already enjoyed playing the nine-hole course at Seaside and a full eighteen at Gearhart. Astoria was built on the land claim of an early settler who'd reached the Clatsop Plains by wagon train over the Oregon Trail in 1845. Today it is revered as a historical golf institution by Oregon insiders, and a hidden gem by national experts who "rediscover" the unique layout every few years.

screaming obscenities at his critic, then heaved both of his poles, javelin style, at the defenseless rider above.

"Put a pretty good turn on the first one and got the guy in the stomach," Grant recalls. "But he pushed the second one right."

If you can manage to drive past Salishan and resist the powerful urge to hit balls up the lush, green hill at its ever-so-close and inviting range, at least take the time to drop by the pro shop for a tale or two. Grant Rogers would be the leading money-winner if there were a story tournament.

The renowned Salishan, near Lincoln City, perennially places on best-in-the-West lists. This recently refurbished and meticulously conditioned course now boasts sod-faced bunkers, à la Scotland. "Just so people know

this course is a little different," explains Rogers. And so it is. The claim here is that in thirty-four years of heavy play, only nine golfers have been known to break seventy at Salishan.

"But beginners and intermediates like it too," Rogers adds. "They enjoy playing a real coastal course, and the holes are fair. Just not that easy."

Also on the Central Coast, one of the best of what the OGA's Jim Gibbons calls the "mom-and-pop courses" can be found at Agate Beach, just north of Newport. To be accurate, it's actually more of a son-mother-uncle operation.

"I think people like to play here because it's friendly," says Romona Martin, whose late husband, Bill, acquired the course in 1960 after operating the popular Forest Hills course west of Portland for years. Romona's son, Terry, who is also the Agate Beach pro, operates the well-maintained, nine-hole layout with the help of uncle Bob Gabelman, who works some days in the pro shop, some on the greens crew.

We played an enjoyable nine with Romona, who looks as if she might have just stepped from the Senior LPGA tour, and brother Bob, who lives in a bandbox beauty of a house just off the 6th tee and is the only guy I've ever seen who plays the game wearing a golf shirt, shorts, and suspenders.

What golfers want most of all, Romona figures, is to have a good time. "Always remember," she says, "the world is full of a lot more amateurs than professionals." And so at Agate Beach, golfers are allowed to bring along their dogs (the Martins' golden retriever, Brodie, often lounges just outside the pro shop, gnawing on a discarded headcover), and nonplayers are even encouraged to walk along with golfers free of charge.

Bob Gabelman, a good player, offers yet another compelling reason to visit this nifty nine-holer: "One thing about Agate Beach," advises the sixty-three-year-old while searching for a lost ball in the woods, "there aren't any snakes and there's no poison ivy!"

If Oregon golf's history is found on the North Coast, its future surely lies to the south. First at the spectacular Sandpines in Florence, which, when it opened in 1993, was named the best new public course on the planet by virtually every expert reviewer. Architect Rees Jones gave

A weathered tee marker at Astoria Golf Club to the North, and an old aerator at Bandon Face Rock Golf Course, the short, economical track to the South in Bandon, have both served golfers well since the 1920s.

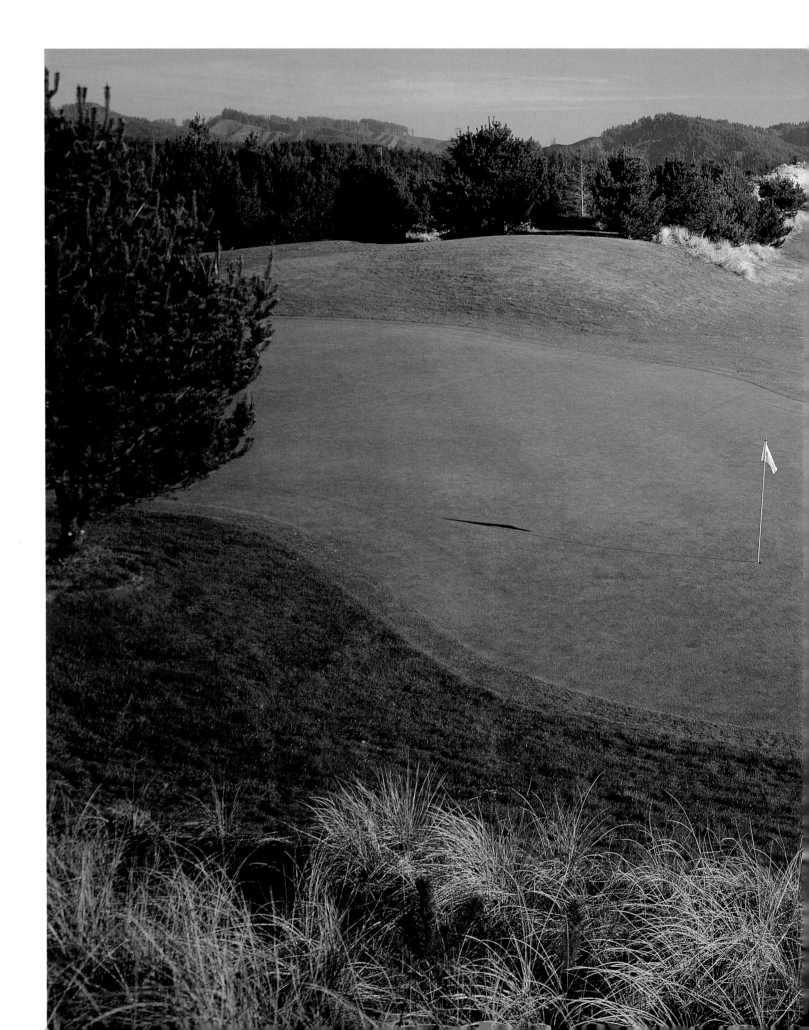

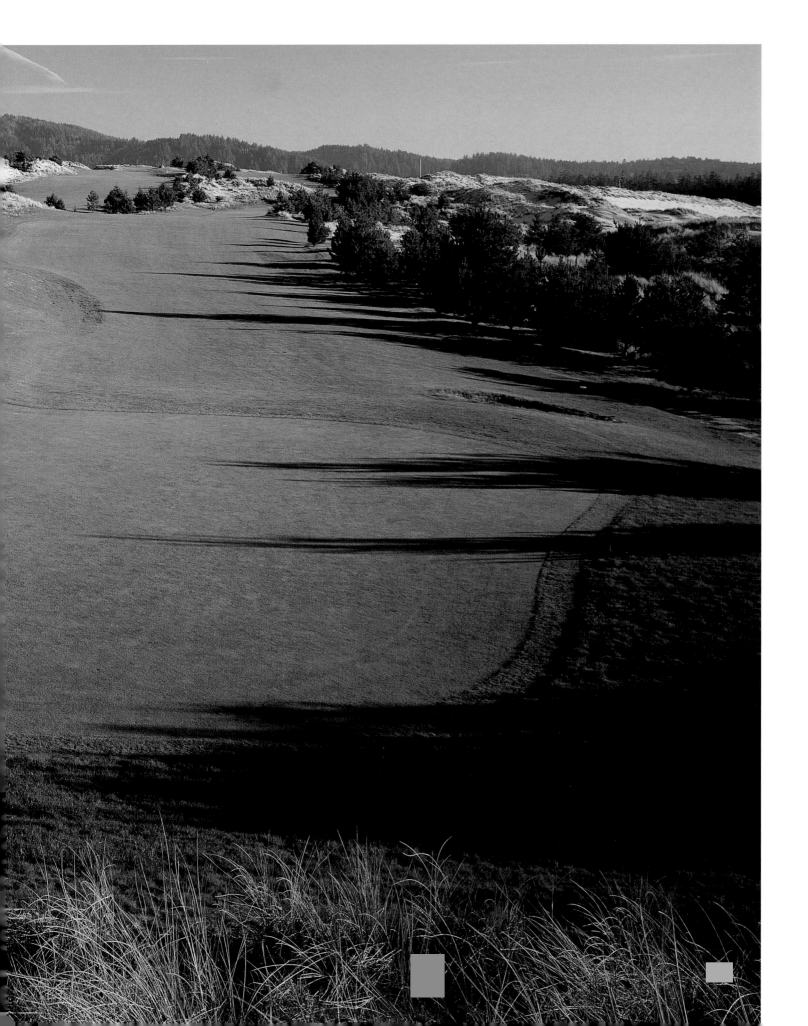

The Oregon Coast

◄ *Perhaps no course in Oregon has experienced a greater turnaround than Ocean Dunes Golf Links in Florence, thanks to owner and architect Bill Robinson, who has designed or redesigned hundreds of others. The lengthening of Ocean Dunes and the addition of a second nine in the early 1990s—along with the fact that most holes are bordered by the world's biggest sand trap, Oregon's dunes—make this well-conditioned links-style course an extremely fun place to play.*

the state a sparkling original, which wanders over dunes and in and out of stands of shore pines.

Many of the holes at Sandpines provide a chance to experience links golf at its best, while the remainder are like parkland. Play the course on a still morning, then play it on a windy afternoon, and you've played two different courses. Sandpines pro Pat Aiken says that people still come from all over the country to try it simply because it was judged the best of the new courses at its inception in 1993.

But that honor was bestowed on Sandpines six years before the opening of Bandon Dunes, located still farther south in Bandon. (This new course should not be confused with Ocean Dunes, a links tester whose sand-bordered fairways in Florence challenge the best of golfers.)

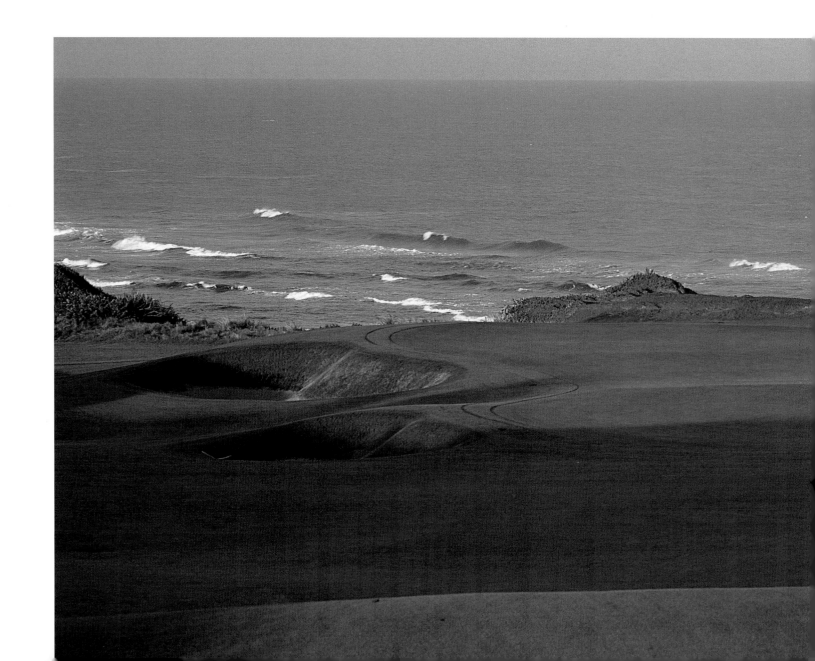

To characterize Bandon Dunes as "Pebble Beach North" is no under-statement. It is a spectacular expanse of gorgeously green fairways, punctuated by natural mounds of beachgrass and sand, and even before it opened for play in spring 1999, visiting golf writers complained there weren't enough superlatives to describe it.

In a state that has some 430 miles of Pacific coastline but a scant few holes where you can actually see the ocean, seven holes at Bandon Dunes run next to the Pacific, and all eighteen have an unobstructed, twenty-three-mile ocean view. The course was designed by a young Scot, David McLay Kidd, who at thirty became the first Scottish architect to create a course in the U.S. since Donald Ross.

I've had the good fortune to play the best courses in Scotland, from

▼ Bandon Dunes embraces the Pacific Ocean at virtually every turn. Despite its remote location—250 miles from Portland and 100 miles from the California border— the golf world buzzed about it long before the course opened. Golf advised its readers that courses like this come along once in a lifetime.

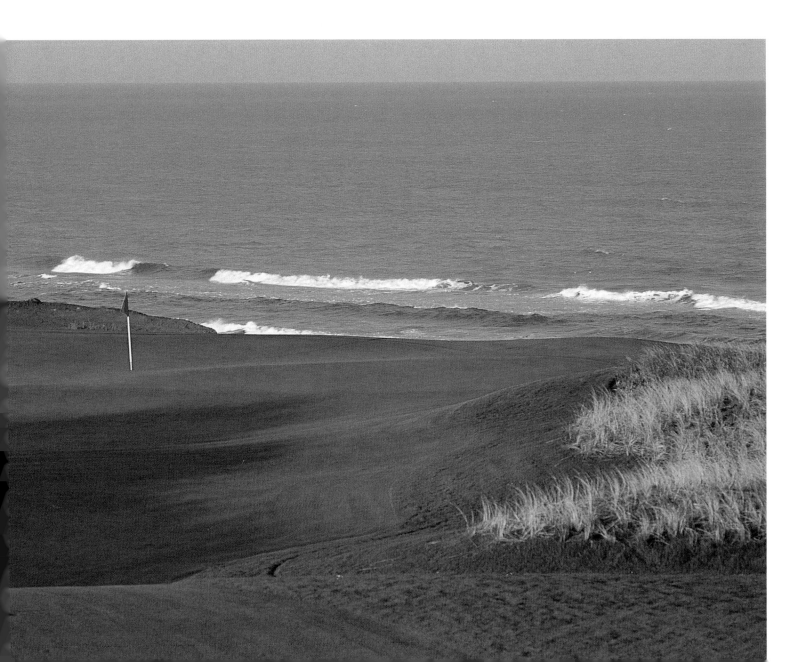

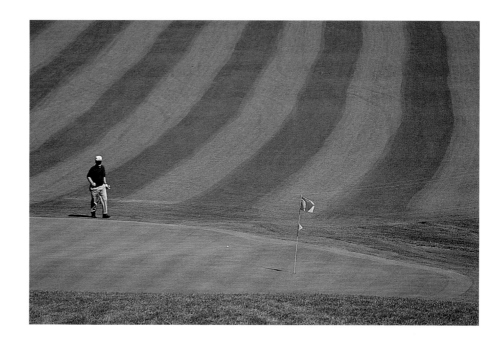

► *Coos Country Club, in Coos Bay, is the work of H. Chandler Egan, the former U.S. Amateur champion who had a hand in the design of several historic Oregon courses.*

▼ *Since Olalla Valley Golf Course in Toledo is a hilly affair, the triangle is used to let the group behind know when the green is clear, not to call cowhands to chow. Few can resist giving it a ring or two, even when no one's waiting on the tee.*

►► *One of three lakes on Sandpines Golf Course runs the entire length of both the par-3 17th hole, and the par-5 18th, creating what can prove to be an enticing invitation. There's plenty of room to bail out on the right in both cases, but risk taking it over the water just a bit, and the reward can be great!*

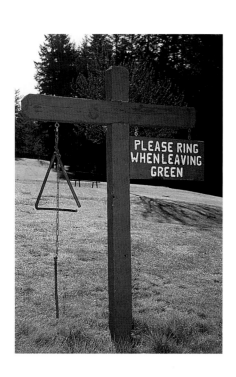

Royal Dornach to St. Andrews. I've also seen the best work of the world's most highly acclaimed golf course architects, from Ross's Pinehurst #2 in North Carolina to Mackenzie's Cypress Point on the Pacific headlands of California. Were they alive today, I believe Mackenzie and Ross would find themselves right at home at this new Oregon upstart, Bandon Dunes. And two more eighteen-hole courses are planned for the site.

Over one weekend, I played at Bandon Dunes and at Sandpines—for me, a true dream trip. My youngest son, Adam, joined us at Sandpines from the University of Oregon, an hour away in Eugene, and literally shouted with joy when I holed my second shot of the day from 163 yards for an eagle on the first hole.

Even on a short excursion, visitors to these South Coast gems will likely encounter a variety of conditions and situations that make their game especially Oregonian. They might tee it up in a little morning fog, then play the back nine under afternoon sun. Often there are gusts of wind strong enough to drastically change yardages at both layouts. But regardless of the weather, the seaside backdrop will almost surely help frame memories of good shots, and ones sooner forgotten.

Above all, visitors are sure to go home with a deeper understanding of links golf, and of their own strengths and weaknesses as players.

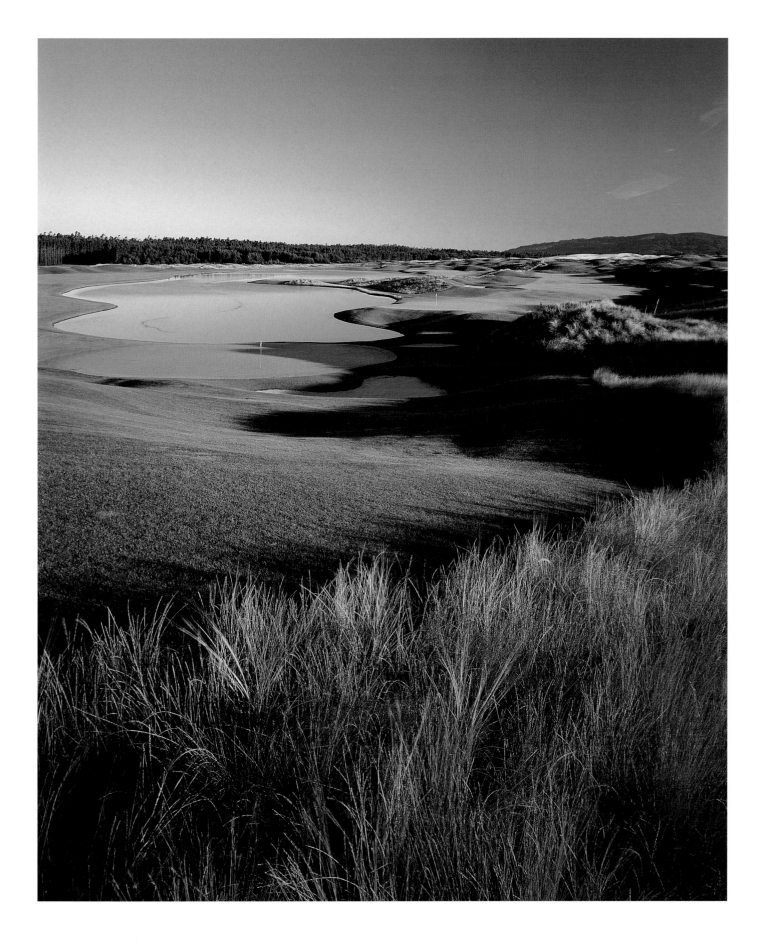

The Oregon Coast

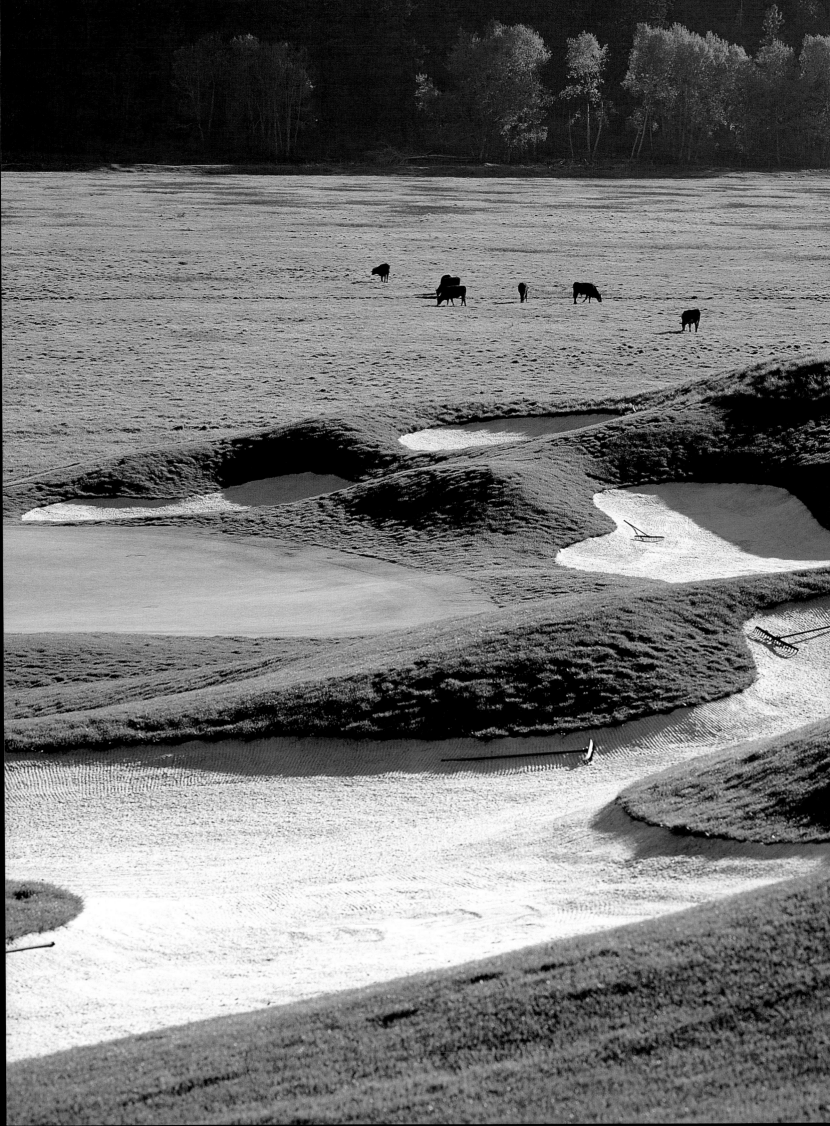

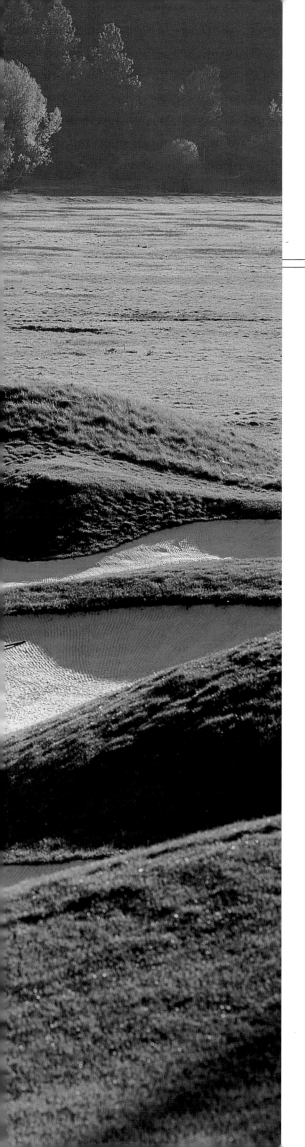

UP THE MIDDLE

SOUTHERN OREGON
through the
WILLAMETTE VALLEY

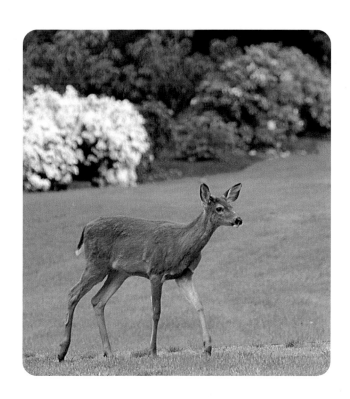

By at least one reckoning, the number-one golf course in Oregon is located in the southern part of the state, ten miles west of the town of Klamath Falls—or, as a visiting writer described it, "on the outer edge of the middle of nowhere." But never mind that. The only person known to have played every course in the state has declared Running Y Ranch Resort to be the best.

◄◄ *Give me land, lots of land. . . . Grazing cattle pretty much ignore golfers at the Running Y Ranch Resort near Klamath Falls. But they aren't the only critters that may be encountered there. More than five hundred different species of wildlife have been identified in what backers simply refer to as "the next great place."*

◄ *A doe at Michelbook Country Club might actually receive scant attention from locals. Deer are regularly sighted on nearly every course in Oregon, except a few in the Portland metropolitan area.*

▲ *Springtime in Josephine County. Colonial Valley Golf Course is an executive length, golfer-friendly layout in Grants Pass.*

Larry Davis is a fifty-five-year-old mechanical engineer from Portland who designs circuitry for ear implants. One day five years ago, while studying a map of Oregon courses, Larry realized he'd already played many of them, and he decided to visit each and every course in the state. He would find out over the next three years that his map listed only 136 of the 203 existing courses. But that didn't keep him from meeting his goal.

He traveled every weekend, usually leaving on Friday afternoon and returning home late Sunday night. He drove nearly 23,000 miles, thought nothing of rising at 3 AM to make a 6 AM tee-time, and kept meticulous records of every eagle (2), birdie (61), par (832), bogie (1,136), and other (535) that he scored. When there was no motel, Larry slept in his car. On one weekend alone he traveled 1,100 miles. Over the course of a single day he played seven different courses.

Surprisingly, the golfers Larry met and played with on his excursions didn't ask him which courses he liked best. They asked if he was married.

"Yes, and my wife is very supportive of me in this," he explained. "She thinks I'm crazy, but she's supportive."

In 1997, near the end of his remarkable golf odyssey, Larry invited me to join him as he realized his goal of playing every course in the state. He had saved for last the outstanding Witch Hollow course, the private side of renowned Pumpkin Ridge in Cornelius, west of Portland.

Larry was an enjoyable and easygoing golf partner. Long ago he had developed an accepting attitude about whatever might happen with his next swing. Whether he scored a par or a bogie, he'd calmly record his results and move on to the next hole and the next course.

As we walked along the Witch's lush fairways, Larry recalled putting on sand greens (there are not many of those left in the entire country) at Woodburn Golf Club; hitting from crushed quartz sand traps at Laurel Hill (which is actually located in Gold Hill and calls itself "the toughest nine in Southern Oregon"); and playing the only six-hole course in the state, Kinzua Hills in Fossil. He has also played a three-holer, Paradise Ranch in Grants Pass. While pursuing his record, Larry walked five

O R E G O N G O L F

hundred miles on courses flat and hilly, hit to 2,772 greens, attempted 3,680 putts, and arrived at two major conclusions. "There are no bad golf courses in the state of Oregon," he reported. "They're all beautiful. And Running Y in Klamath Falls is the best—my number-one course."

Since completing his tour, Larry Davis has spent more time at home reacquainting himself with his grandchildren, but scores of other golfers have since visited Southern Oregon to confirm what he found at Running Y. In 1998, *Golf Digest* named it the "best new affordable golf course in America."

Located on the shore of Upper Klamath Lake on ranch land formerly owned by Walt Disney's brother Roy, the Running Y Ranch Resort

A member of the Audubon Cooperative Sanctuary System, the Running Y golf course epitomizes designer Arnold Palmer's philosophy of blending the course with the natural environment.

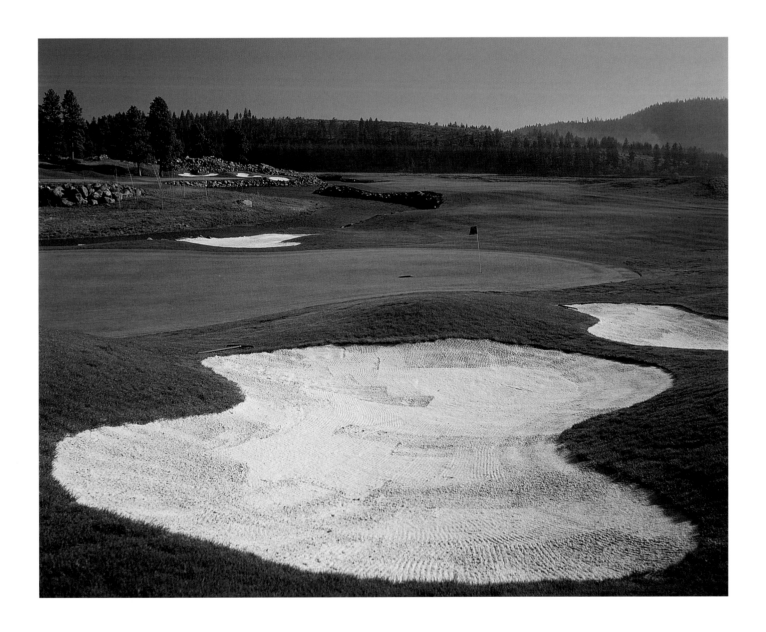

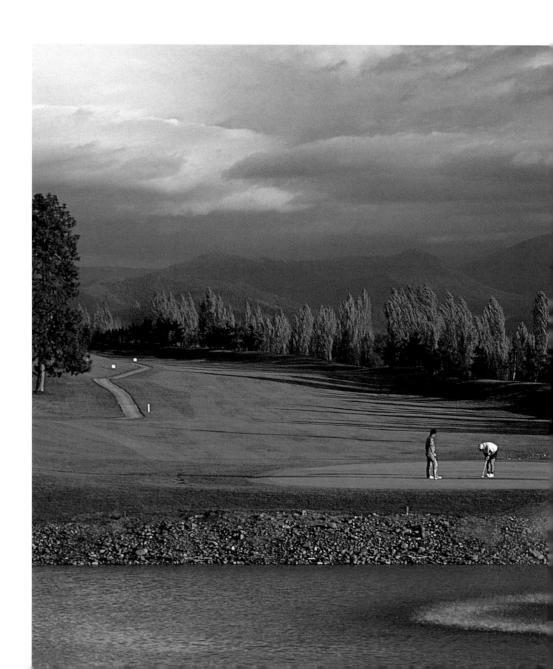

includes rugged mountain rangeland and sensitive wetlands, and is home to more than five hundred native species of wildlife.

We played the course on a bright summer morning with resident pro Jim Skaugstad, an affable trickshot artist (he can hit a ball straighter and farther with a shovel than I can with a 7 iron) and winner of both the Oregon and Washington senior titles. As we teed off, herds of cattle ran across the range next to the glorious first two holes. "Where are they running to?" I asked Skaugstad. "I have absolutely no clue," said the pro.

"Skags," as he is known in Northwest golf circles, was still flying high from his round a few weeks before with Arnold Palmer, who helped design Running Y. When their exhibition match and its substantial gallery reached the par-5, 521-yard risk-and-reward 17th hole, Skags pointed

Located near Medford, Eagle Point Golf Course is a most welcome addition to Southern Oregon golf. It joins the permanent course rotation in hosting both the Oregon Amateur and Oregon Senior Amateur, a clear indication of both its quality and playability.

O R E G O N G O L F

out the postage stamp alternate fairway nearly hidden in surrounding bunkers and tall fescue grass to the right of the regular fairway. Risk the alternate successfully from the tee and you're rewarded with a shot home, and a possible eagle, of only about 200 yards.

"That's your fairway over there, Arnie," Skags explained. "You added that to the design." Running Y was actually a joint creative effort of the Palmer design team and John Thronson, superintendent of Central Oregon's fine Eagle Crest Resort. "Then I guess I'd better go for it," Palmer replied. He then hit the diminutive target with his driver, reached the green in two with a five-wood, missed his eagle putt, but made birdie with a routine two-putt.

Skags took the more conventional route, finding a fairway bunker

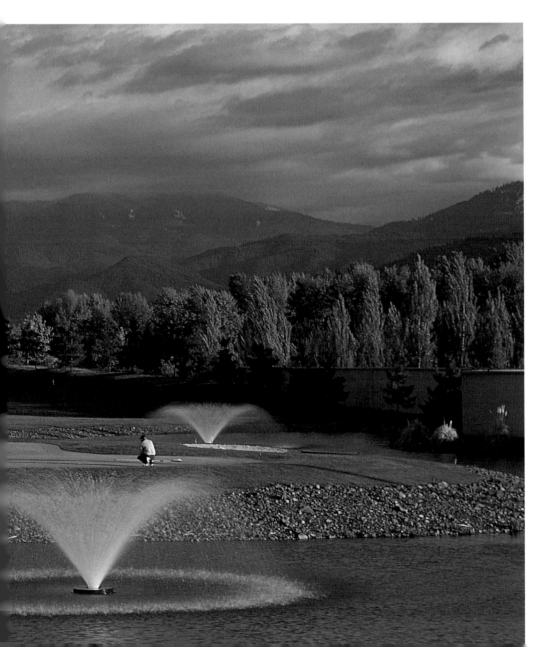

The rolling hills of Southern Oregon provide a scenic backdrop to playing Quail Point Golf Course, a semi-private track located in a retirement community in Medford.

When it opened in 1996, Eagle Point, near Medford, appeared immediately in national rankings for both affordability and accessibility. Its design incorporates several man-made wetland areas for the proliferation of wildlife. Parallel fairways and multiple tee boxes make it eminently playable for golfers of all skill levels.

with his drive but still managing a journeyman's par to the King's birdie. "I thought it best to go left and leave Arnie alone with his adoring gallery on the right," Skags said.

Earlier in the day, Palmer had circled the course in his Gulfstream jet, and before leaving he told locals he looked forward to returning with friends to play golf and relax. This was high praise from golf's undisputed king, who can play golf and relax any doggone place he wants. But duffers from Seattle to San Francisco will no doubt echo Palmer after visiting Running Y. In the parlance of the west, the ranch may be just a greenhorn now, but it's a spread every swinging cowboy's going to want to work.

There are other inviting new venues in Southern Oregon as well.

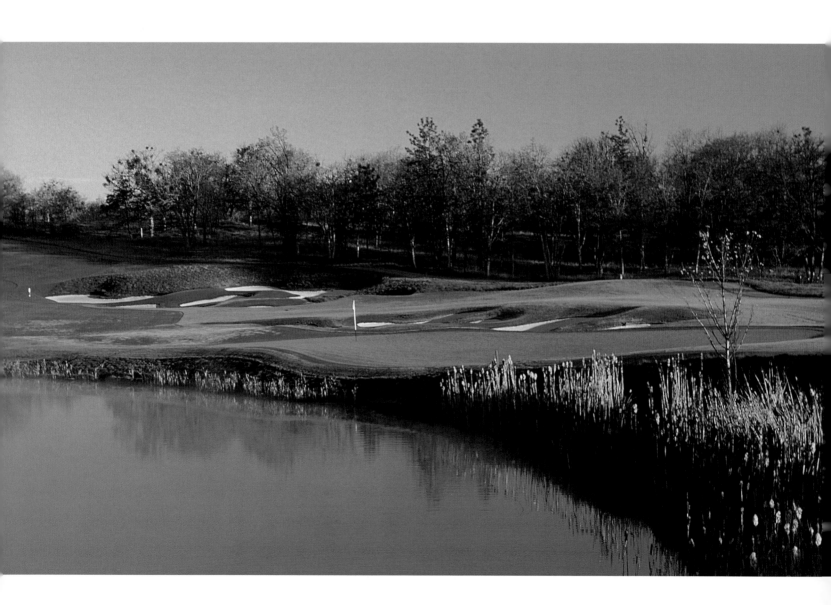

Visitors to the Running Y should also travel about an hour west on Highway 140 to the Medford area and the Eagle Point course designed by Robert Trent Jones, Jr., and the only course out of the nearly two hundred designed by Jones that he owns. *Golf* magazine named Eagle Point one of the "top ten you can play" when the course opened in 1996. We found the course to be in impeccable condition, and enjoyed the wetlands that border the course and the many wooden birdhouses built on neighboring land that was once a pear orchard. Residential development on the front nine, which might have otherwise detracted from the championship course, is more than outweighed by distant views of Mount McLaughlin. A massive totem pole near the 18th green fits the place perfectly, a distinctive sentinel reminding all that this is golf, Oregon style.

The *New York Times*—and from this we must conclude that the newspaper of record does publish "All the News That's Fit to Print"—ranked Eagle Point among the best courses in the Northwest.

But even the *New York Times* may be unaware of another fine course in the same neighborhood. In fact, when we first drove by Stoneridge Golf Club, which you can see from Highway 140, we thought it was the Eagle Point course, a mistake probably made by many. The two are not only in close proximity, located roughly on opposite sides of the same highway, they've also been favorably compared by players who've tried both.

Stoneridge owner Jim Cochran, a contractor by profession, spent half a year traveling, playing, and studying courses in the west before he built his, a beauty where virtually no two holes are alike.

"I had the land, and we needed golf courses here," Cochran said when I asked what had possessed him to go into the golf business. "Of course, everybody else around here decided to build golf courses too, so I guess it was a good idea!"

Stoneridge has a unique history. On this site during World War II, soldiers from nearby Camp White, training for duty overseas, used the stone walls built by homesteaders in the 1860s to replicate conditions they'd find on battlefields in Europe. Some of the short walls remain today, winding their way through holes 2 and 3, a curious sight likely to

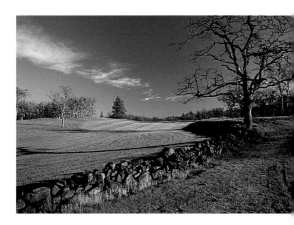

The remaining rock walls at Stoneridge are a curious site on a golf course but don't really come into play. Nearby Eagle Point Golf Course, and Klamath Fall's Running Y, about an hour away, combine with Stoneridge to make this golf locale one of the fastest growing in the state.

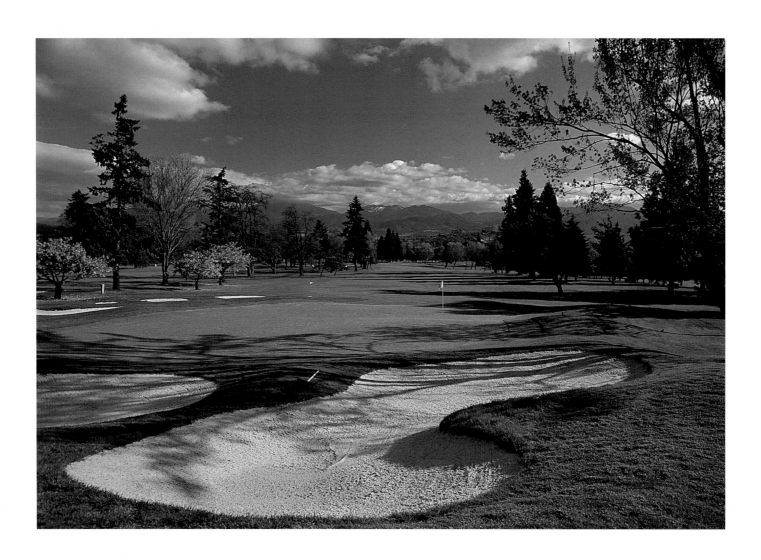

The largest private club in Southern Oregon, Rogue Valley has been in operation since 1920. It boasts twenty-seven holes to meet the playing needs of its members.

cause passing golfers to ponder the time when this ground was used for a more serious purpose.

We enjoyed this place, named best affordable course for 1998 by *Golf Digest*. It's hilly on the front, flatter and watery on the back, with much risk and reward, and many holes bordered by unusual-looking oak trees.

This part of the state is also home to some formidable private courses, including the Rogue Valley Country Club in Medford, a twenty-seven-hole affair that annually hosts the Southern Oregon Amateur, the largest match play tournament west of the Mississippi. The course was designed by Medford's own H. Chandler Egan, a 1902 U.S. Amateur champion, who designed Portland's Eastmoreland course, among others.

Reames Golf and Country Club (Egan again) in Klamath Falls, with its views of Mount Shasta, and Grants Pass Country Club, which is open

O R E G O N G O L F

to the public, are also worthy tracks. These two, along with Eagle Point and Stoneridge, made Larry Davis's Top Ten list (see page 49), yet another indication that golf in Southern Oregon is more than keeping pace with the rest of the state.

Like Highway 101 on the coast, the I-5 corridor up the middle of Oregon, which runs from the rolling hills and river valleys of Southern Oregon to the flat farmland of the Willamette Valley, takes visitors past a variety of enjoyable courses, many of them nine-holers. In our summer of golf travel, Vicki and I found that many of these nine-hole courses afforded us just the right amount of time to play, get a sense of a place, and move on.

Beginning at the "southern end of the corridor," Oak Knoll in Ashland

Southern Oregon's mild climate has proved to be just right for the madrona trees that border some fairways at Grants Pass Golf Club. The club's junior program is responsible for the development of several state amateur and high school champions.

Members at Illahe Hills Country Club, in Salem, know the playing season has arrived when the cherry trees bloom on number seven, the course's signature hole.

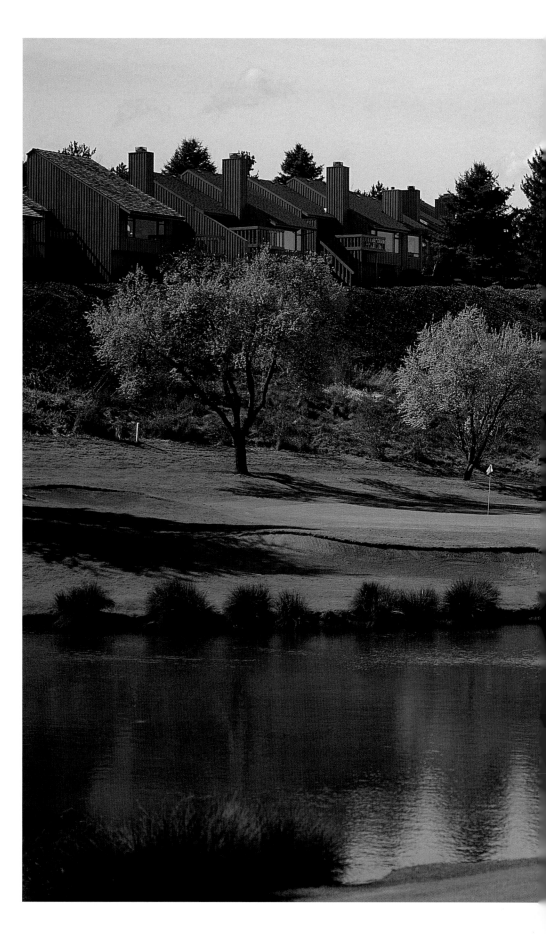

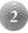

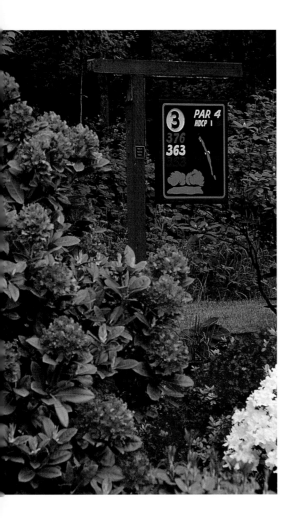

While one Oregon golf course was originally named in honor of the rhododendron (Rhodo Dunes, which is now Ocean Dunes, in Florence), these beauties welcome players at Michelbook, in Yamhill County. The private club carries the name of the farmer who sold his land for the course, but is commonly mispronounced "Michelbrook" by even longtime Oregon golfers.

provides a pleasant alternate activity to playgoers attending the Oregon Shakespeare Festival. Medford visitors can enjoy outings at Cedar Links, Bear Creek, and Stewart Meadows, while Grants Pass offers its own collection of enticing venues: Dutcher Creek, Red Mountain, Applegate, and Colonial Valley.

Roseburg may have the toughest ticket in all of Oregon. Only hospital patients or volunteers are allowed on the Roseburg Veterans Hospital Golf Course, dubbed "Aspirin Acres" by regulars who have more than earned the right to tee it up there. But if gaining access to exclusive venues is your game, shoot a little higher and go for the Roseburg Country Club, an inviting mix of the traditional and contemporary alongside the North Umpqua River.

Farther to the north, Emerald Valley in Creswell and Trysting Tree in Corvallis, both on the banks of the Willamette River, attract their share of play. Trysting Tree, a links course that is home to the Oregon State University golf team, was named after an early-day meeting place for courting couples on the OSU campus.

Private courses not to be missed along this stretch are Shadow Hills in Junction City, a popular tournament site for state and regional competition, and Corvallis Country Club, a tree-lined beauty where Bob Gilder, a six-time winner on the PGA Tour, played his early golf. It's further evidence that we damp-climate natives can mix it up with the best from golf's good-weather states.

Spring Hill Country Club in Albany is a private course with an unusual layout—six par 3s, 4s, and 5s, with no two of the same coming back to back. The state capital of Salem also boasts some eminently playable tracks, including the semiprivate and historic Salem Golf Club, and the private Illahe Hills Country Club, which has hosted the U.S. Girls Junior Championship.

The Peter Jacobsen–designed Creekside Golf Club, a relative newcomer to the Salem area, is unquestionably challenging to the first-time visitor. Strategy is especially important on this circuitous layout, which places a high premium on course management. The most notable is

Creekside's 17th green, backed by the sheer brown cliff of an old rock quarry, a striking contrast to the green hues predominant on the rest of the course.

As fine as these places are, none compares with my runaway favorite in this part of Oregon, Eugene Country Club. I first played it with Portland professional Byron Wood in the Eugene Pro-Am, beginning the day before dawn with a full ranch breakfast at Byron's parents' house. His dad, Wendell, now well into his eighties, retired as Eugene's head pro in 1977 after forty-two years of service to the club. He started caddying there as a youngster, even packing once for the legendary Walter Hagen (counting some twenty-two clubs in the great pro's bag!), and later played in exhibitions with the likes of Ben Hogan and Byron Nelson. All of them loved Wendell's home course.

Golf à la cart at Trysting Tree in Corvallis, home of the Oregon State University golf teams and previous site of the Pac-10 Conference Championships.

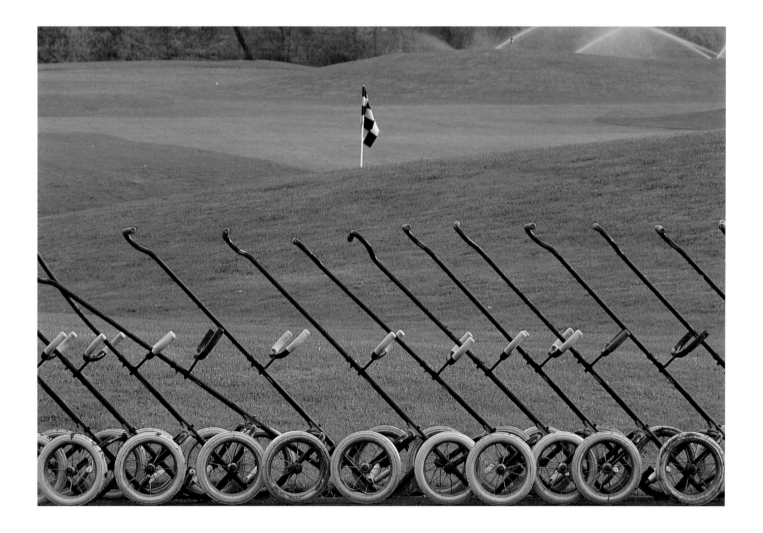

Many Oregonians consider Eugene Country Club, which opened in 1899, to be the best the state has to offer. National experts tend to agree, often listing Eugene as one of America's top 100 courses. Old-timers claim it was always beautiful, but that the course was made even better when it was renovated in 1967, "making every hole a beautiful picture," according to one regular.

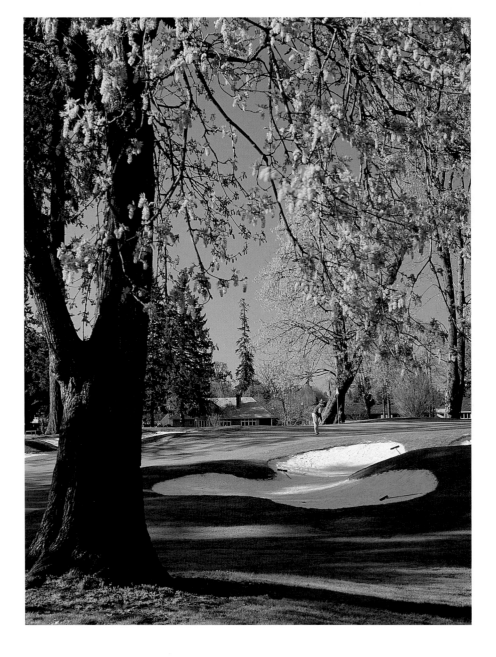

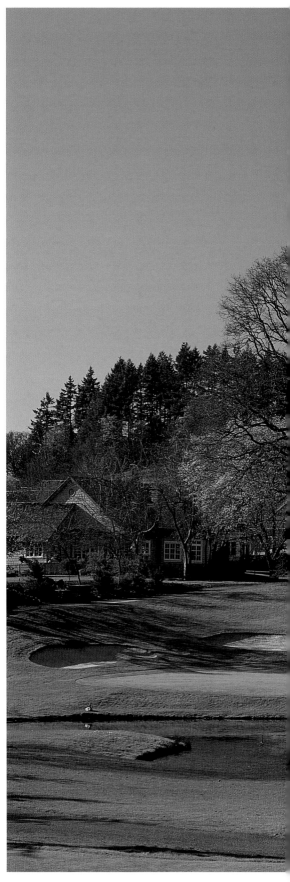

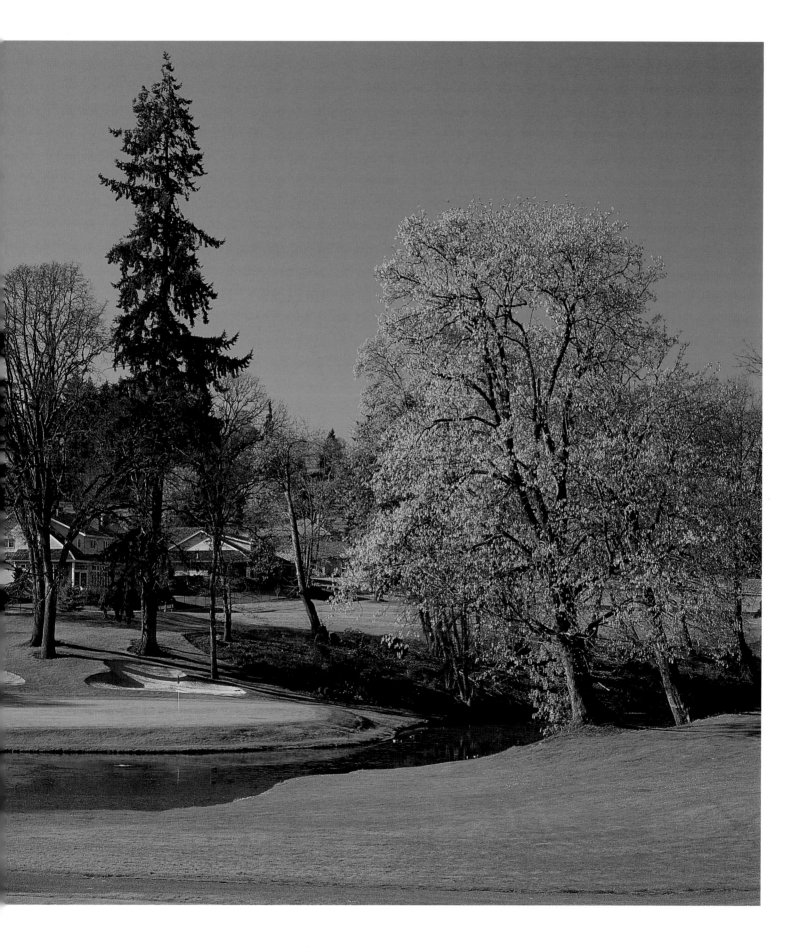

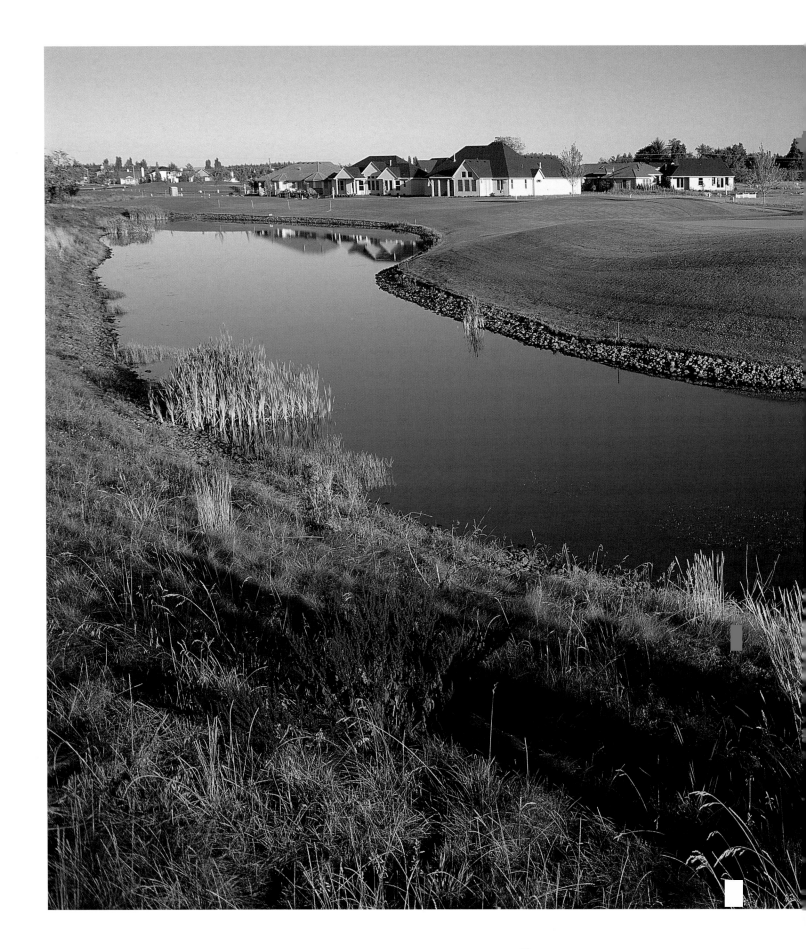

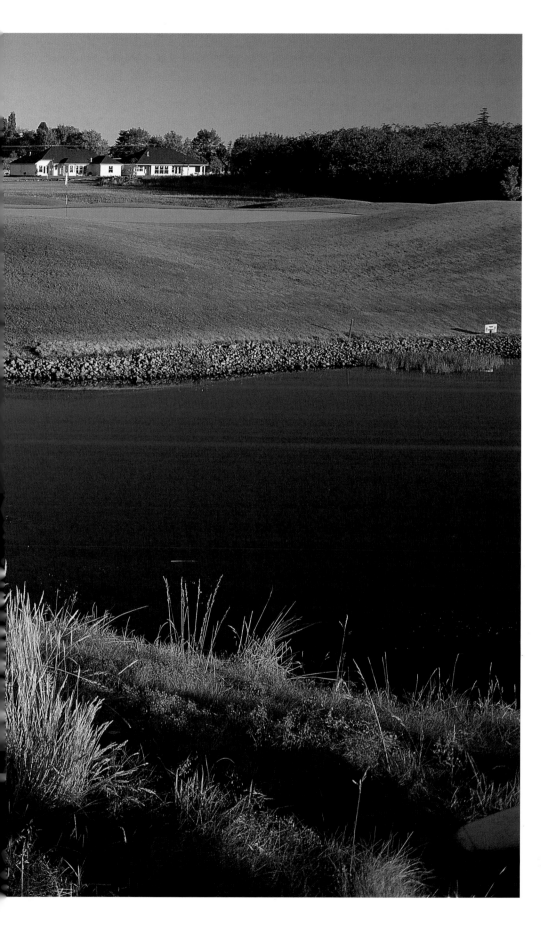

Tukwila in Woodburn is surely the only golf course in the world that has 53,000 owners.

Two decades ago, the leaders of the Oregon Golf Association had the foresight to recognize the growing need for affordable and accessible public golf courses. They decided to add an additional dollar to membership fees, then carefully invested the extra revenue.

The result is the OGA Members Course at Tukwila, which opened in 1994 as only the second course in America built by a state golf association. (Poppy Hills, the work of the Northern California Golf Association, was first.)

Tukwila is a Native American word for the filbert. The course, constructed on the rich, sandy soil of a large filbert orchard, part of which still borders some fairways, is well liked by golfers of all types. When the phones open up for tee times, there are no restrictions: it's first-come, first-served for men, women, and juniors.

"It gives back to the game, and benefits the entire golfing community," beams OGA Executive Director Jim Gibbons. "I think it's pretty neat that 53,000 members contributed to its development, and our leadership had the vision to make it happen."

And the list of owners is still growing. All who get handicaps at their home course in Oregon are automatically signed on!

Over bacon, sausage, eggs, and Mrs. Wood's homemade biscuits topped with delicious strawberry freezer jam, Wendell chatted enthusiastically about Eugene CC, where he claims to have never had a bad day at work.

"I don't know of a course in the world like it, or that has the tree population for size and interest," he said. "The firs are at least five hundred years old, and many of the big leaf maples are three hundred and four hundred years old. They're immense and of course come into play on almost every hole."

Despite the fact that I played poorly during the tournament, I fell in love with this stately beauty, a traditional parkland design. Wendell

It's not a misnomer; Shadow Hills in Junction City was constructed on what appears to be flat farmland. The course was named for surrounding, distant hills, which in certain light take on a blue hue, like shadows.

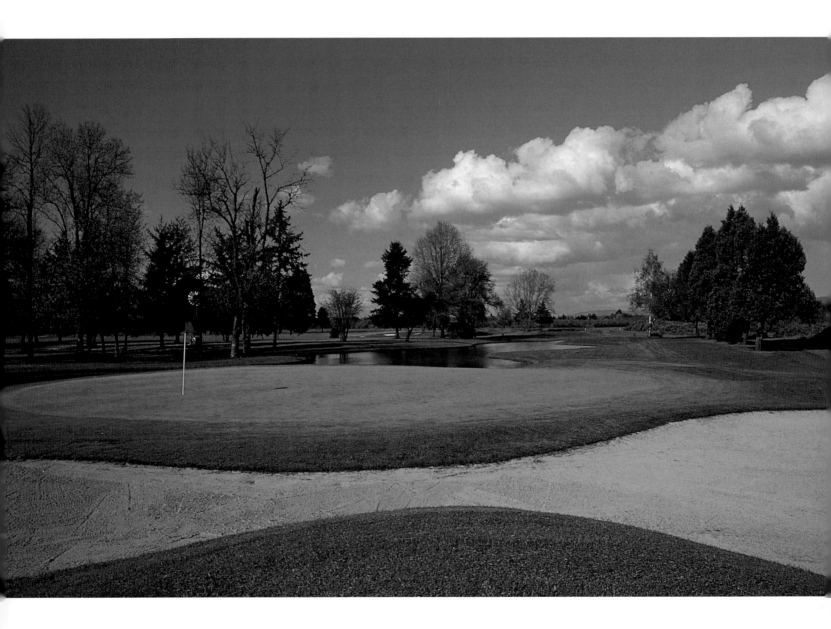

O R E G O N G O L F

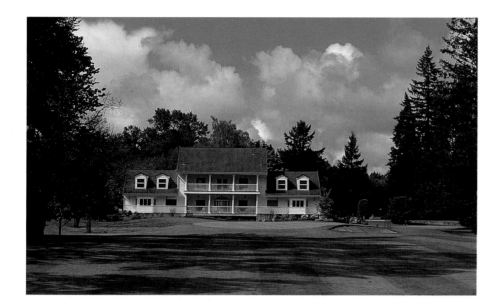

The clubhouse at semiprivate Salem Golf Club is only a stone's throw from the Willamette River, but its colonial design might fit just as nicely in New England. It's a refreshing departure from the more traditional Northwest look.

later explained that the large trees tend to minimize distances—that a two-hundred-foot tree behind a green will make the target appear closer. "Our vertical hazards," he mused, "are our main hazards."

Longtime players at Eugene, Wood included, believe this already great golf course became even greater with a Robert Trent Jones, Jr., remodel in 1968, which reversed some holes, added a little water, and gave the fine old place some modern architectural touches. (Eugene CC was originally the work of H. Chandler Egan.)

Jones told Wood that he believed many of the new holes were among the best he'd ever made, citing specifically the 15th green as "the most natural, playable green position" he had designed anywhere. Play this par-4, slight dogleg and you'll see immediately what he meant. The green rests comfortably atop a natural shelf, backed by a single conifer and several deciduous trees, which stand like an attentive gallery. Just the walk up the short, steep slope to reach the putting surface seems somehow to be a joyful golfing experience.

Experts of every stripe perennially choose Eugene Country Club as one of the top one hundred golf courses in America. But it didn't make the top ten list of Larry Davis, the man who's played them all in Oregon! My hunch is that Larry didn't have breakfast over at the Woods' place before going to the course.

Larry Davis

TOP TEN

1
Running Y, *Klamath Falls*

2
Awbrey Glen, *Bend*

3
Eagle Ridge, *Redmond*

4
Stoneridge, *Medford*

5
Pumpkin Ridge / Ghost Creek
Cornelius

6
Eagle Point, *Eagle Point*

7
Elkhorn, *Lyons*

8
Reames Country Club
Klamath Falls

9
The Dalles Country Club
The Dalles

10
Grants Pass Country Club
Grants Pass

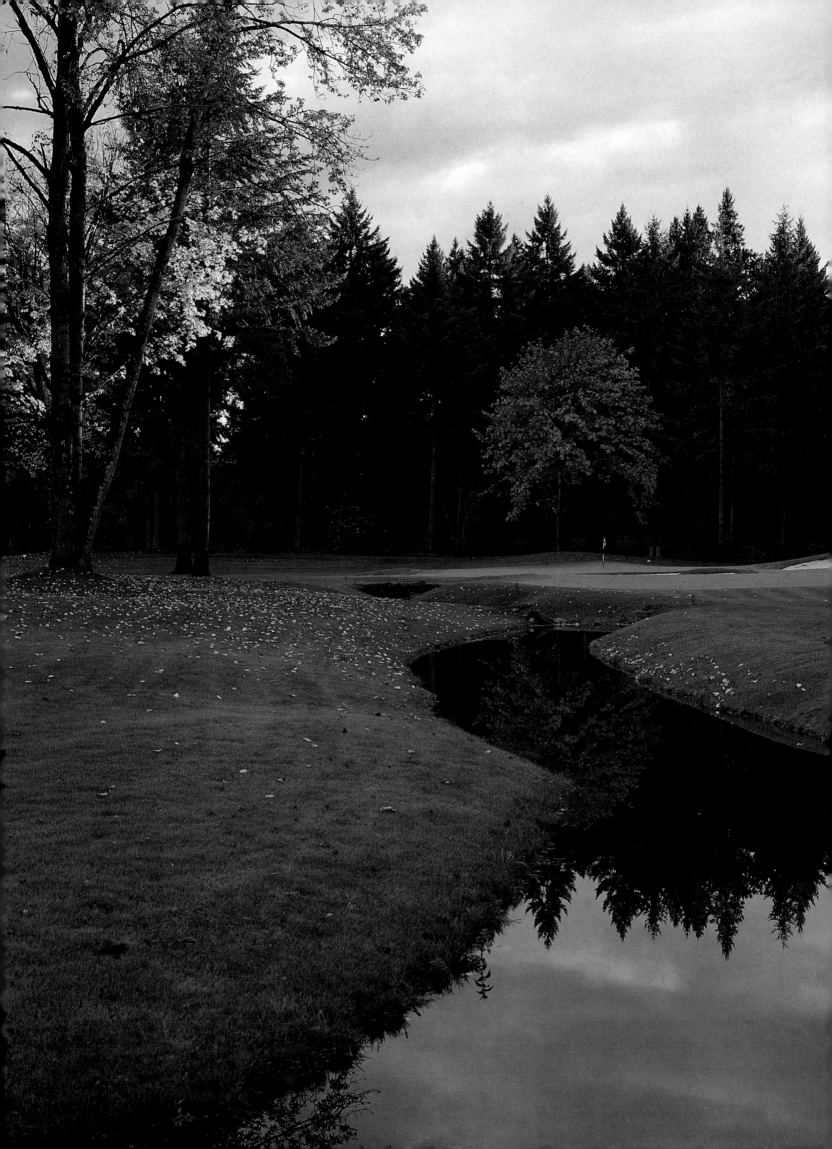

THE HOME HOLES

PORTLAND & ENVIRONS

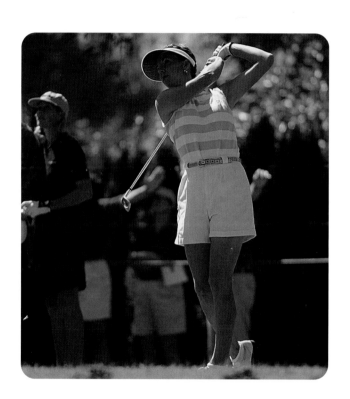

I started going to the Portland Golf Club when I was nine or ten, rising early on bright summer mornings to walk the three miles through the pastureland at Alpenrose Dairy and around the old Nichols Riding Academy property. I'd go over the chain link fence along the road next to the 5th hole (wooden steps went up and over the top of the fence at various places so members could retrieve the balls they had hit off the course), then cross the driving range to arrive at the caddy bench, near the pro shop.

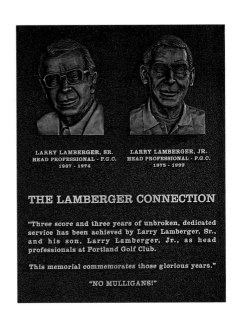

LARRY LAMBERGER, SR.
HEAD PROFESSIONAL - P.G.C.
1937 - 1974

LARRY LAMBERGER, JR.
HEAD PROFESSIONAL - P.G.C.
1975 - 1999

THE LAMBERGER CONNECTION

"Three score and three years of unbroken, dedicated service has been achieved by Larry Lamberger, Sr., and his son, Larry Lamberger, Jr., as head professionals at Portland Golf Club.

This memorial commemorates those glorious years."

"NO MULLIGANS!"

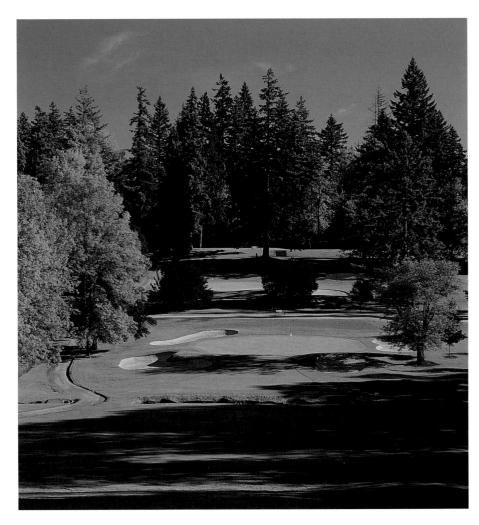

◄◄ *Nowhere are the colors of fall more apparent than in golf. Here, fall is reflected in a meandering creek on the Reserve Vineyard's Fought Course near Aloha, named for its designer, former U.S. Amateur champion John Fought. The Reserve's second track, the Cupp Course, is also named for the man who created it, Robert Cupp.*

◄ *As sure as the colors return to Portland each fall, so too do the best women players in the world for the Safeway LPGA Championship at Columbia Edgewater, the oldest continuous tournament on the women's tour.*

▲ *Few father-son professional teams, if any, have combined for a longer term of service than the Lambergers at Portland Golf Club. Both achieved a status normally reserved for rock stars—single-name recognition. Say "Senior" or "Junior" to any veteran Portland member and no other names are necessary.*

I'd sit with the other kids and the old men we called bums, the word "homeless" still years from use. They would ride the bus out to the course from skid row on Burnside Street in downtown Portland. These men wore large overcoats in all weather, and their pockets always seemed to be stuffed with newspapers. When they were selected for a caddying job—we kids were sure that the members who habitually requested the bums wanted to give them a helping hand—the old men would carefully fold and place their overcoats beneath the caddy bench.

After becoming an "A" caddy at the age of eleven, I usually chose to carry "double." Trudging after two golfers with a bag on each shoulder over eighteen holes of a hilly golf course was tiring but the effort was worth it. The standard fee was $2.50 per player, with a $1 tip from each. I could earn $7 per round, and if up to it, pack for two rounds and go

home with a whopping $14. Some of my friends with paper routes would have to work a month to make that much. So I didn't mind spending a little before I left for home: I'd stop at the back door of the clubhouse kitchen, where the cook would let caddies have a deluxe hamburger for only $1, still the best I've ever tasted.

But my fondest memories of those years are of the golf course itself. I'd never seen such a beautiful place. The fairways, lined with the tallest fir trees imaginable, looked like a virtual forest dreamland. Decades later, the rest of the course is equally clear in my memory: the way tree-shaded Fanno Creek meandered through the layout; the absolute splendor of the perfect, shimmering lake that surrounded the 7th hole and the 11th tee; the unbelievably miniscule blades of grass that covered eighteen flawless putting greens, seemingly smoother than the finest carpet. I wanted to be part of that glorious world forever.

Back then I didn't know that this was where, in 1944, Sam Snead won the first PGA event ever held in Portland; where Ben Hogan won his first major event, the 1946 PGA championship, after which visiting golf writers met in a vacated ice cream stand to organize the American Golf Writers Association; and where member and local businessman Robert Hudson would be personally responsible in 1947 for the postwar revival of the Ryder Cup matches.

In future years, Portland Golf Club would be the site of Dr. Carry Middlecoff's victory in the 1955 Western Open. In 1959 and 1960, Billy Casper would win the first two of his three consecutive Portland Open titles here. Even Jack Nicklaus, the great Golden Bear, would put his stamp on Portland Golf Club in 1964 and 1965, claiming two of his three Portland Open victories there at the outset of his fifteen-year domination of the game. This storied venue would also be the scene of Lee Trevino's tragic collapse in the 1969 Alcan Golfer of the Year Championship, when he blew a six-shot lead with three holes to play, allowing Casper to win a purse of $35,000—then the largest in golf.

This course is also where the top women players from the Ladies Professional Golf Association (LPGA) would compete in their first

◄ *The view from the par-3 12th tee at Portland Golf Club takes in three classic holes as they stair-step up the opposite hill. Above the 12th green, in order, are the 13th tee, 14th green, and 15th tee. The latter is now named Firlock Station for the old Oregon Electric train stop golfers once used to reach what was then an outlying course. Today it's a fifteen-minute drive from downtown.*

▲ *Jake and The Shark (Peter Jacobsen and Greg Norman) share golf insights and humor with fans during Jacobsen's annual Fred Meyer Challenge, which Portlanders have come to appreciate even more than a regular tour event.*

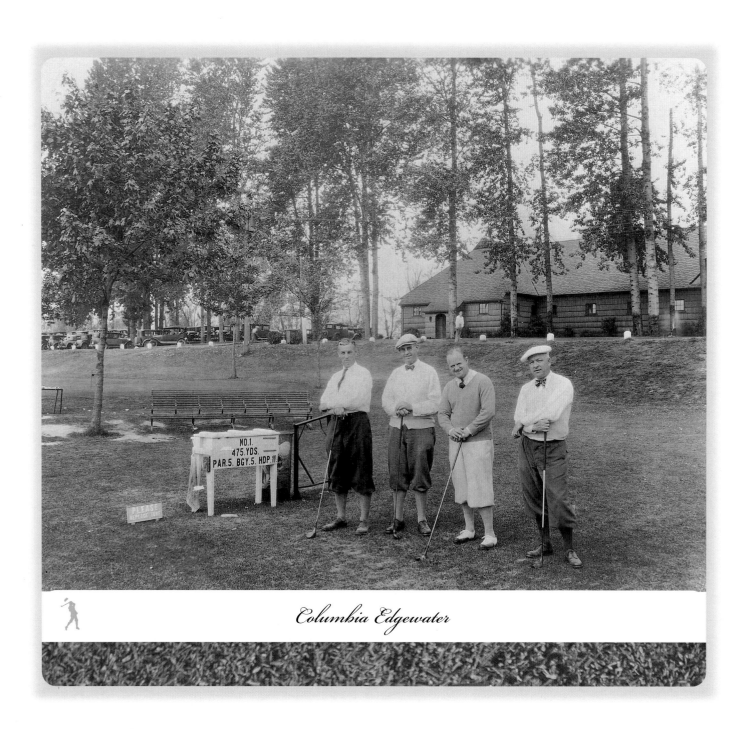

Columbia Edgewater

The men of Columbia Edgewater, where it's generally acknowledged that if you can compete with this Portland country club's best—then or now—you can play with anyone, anywhere.

Portland-area tournaments (1971, 1973, 1975, 1976, 1979); where "Mr. X," Miller Barber, would win the U.S. Senior Open in 1982; and where Peter Jacobsen would stage his inaugural Fred Meyer Challenge in 1986, which still brings the world's best professional players to town each fall and raises millions for charity.

And working behind the scenes at all of these prestigious events were

the same PGC members, men and women, I caddied for as a kid. They are outstanding supporters of the game, like Elon Ellis, who with his golfing friends helped found the old "Trembling Twenty," a group of businessmen who pooled their money in 1955 and gambled that the pro tours would do well if they could be convinced to stop in Portland. The organization evolved into what exists today as the nonprofit Tournament Golf Foundation, whose volunteer members roll up their sleeves every year to stage an LPGA tournament in the City of Roses—now the tour's longest-running regular event.

Sometime before my high school years I stopped caddying at Portland in order to pursue more regular jobs and paychecks. But I returned the year I graduated, 1965, to caddy in the old Portland Open for future two-time PGA champion (and, much later, Senior Tour stalwart) Dave Stockton.

The splendid old place—which I still had never played—had lost none of its appeal. For me, it would forever remain the course that not even St. Andrews or Augusta National could compare with. To play or even just walk this ground is to feel history. And, actually to be part of a Tour event there, even as a caddy, was thrilling. Stockton didn't do well that week, but he was nice to me, and I got to be close to players like Al Geiberger, Mike Souchak, and the ever-colorful Doug Sanders. I will always remember it as one of my favorite weeks in golf.

In the following years I've played Portland, often with Elon Ellis and others I caddied for, and the course is still my favorite. But, I've been perfectly content to play most of my golf at Portland's five, fine municipal courses, each with its own background and character.

Like many people in southwest Portland, I played my very first rounds at the city's Progress Downs course, located just down Scholls Ferry Road from Portland Golf Club. Its uninspired original design was never a deterrent to heavy play, because its location in rapidly growing Washington County made it the most convenient place to golf for untold thousands.

But the course took on surprising new appeal in 1999 when it was completely redesigned by Portland golf director, John Zoller. The new,

▲ *Whether the annual LPGA event at Columbia Edgewater or the U.S. Women's Open at Pumpkin Ridge, women professionals praise the grooming and fine conditions of Portland's courses on every visit.*

▼ *Denizens of the municipal Progress Downs swear they saw Tiger Woods, wearing tape player earphones and seemingly lost in his own world, hitting one ball after another over the back fence of the driving range during a break from his third consecutive U.S. Amateur Championship in Portland. Why not?*

water-enhanced layout will likely assure continued heavy use because it's truly become a course worth playing.

On the east side of town, amidst older and well-established neighborhoods, is a marvelous municipal course, Rose City, the second oldest in the city. This property used to be home to a speedway, where old-timers recall the time when promoters staged a head-on locomotive collision. But sometime in the 1920s, a beginning golfer looking for a place to

Located in a peaceful Northeast Portland neighborhood, Rose City Golf Course is one of the most inviting of the five municipal courses. Its elevated 2nd green requires accurate club selection.

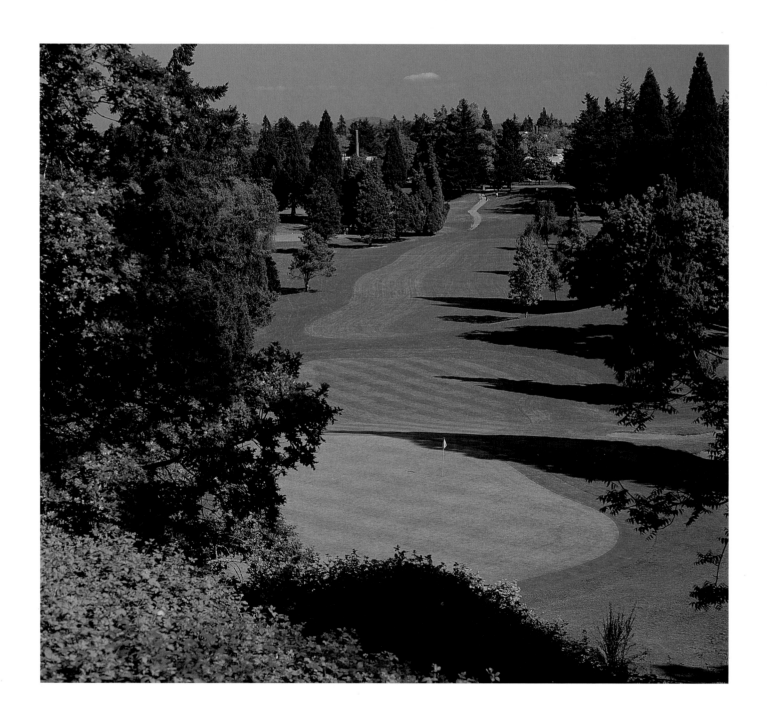

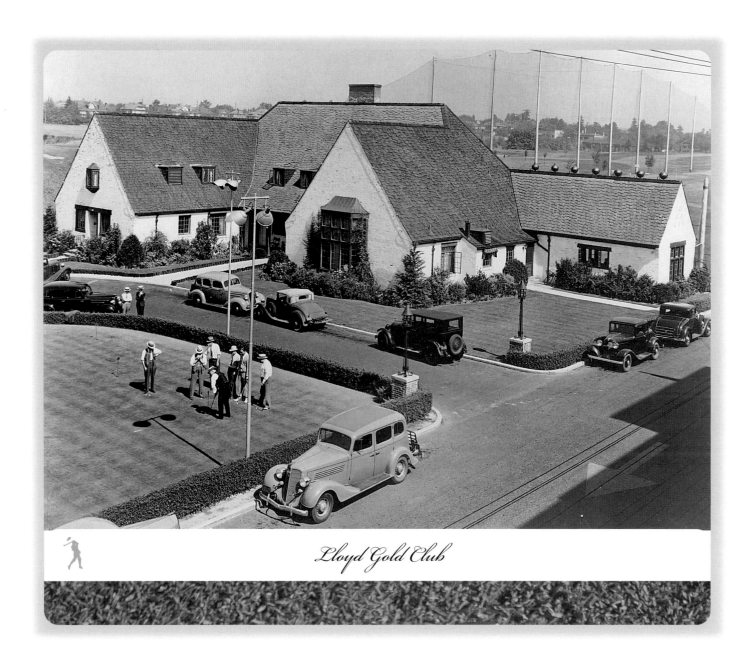

Lloyd Gold Club

practice got permission to sink some tin cans in the infield and the race course soon became a golf course, the two wrecked steam engines remaining for a time as hazards. Since then, Rose City has undergone many facelifts, hosted a USGA event, and remains one of the most playable and popular courses in the city.

Eastmoreland in southeast Portland is the oldest and, many would argue, the best of the Portland city courses. Golfers today are accustomed to new golf development built to enhance adjacent residential sales, but this may be the first course in Oregon to get its start that way.

Even longtime local residents would recognize the building as the old Sweet Tibbie Dunbar restaurant, adjacent to Benson Polytechnic High School in Northeast Portland. But many years before that, it was the clubhouse for the popular Lloyd Golf Club. The I-84 freeway replaced the golf course, and today the stately building serves as a credit union.

Cherry blossoms at Portland's widely heralded Eastmoreland often frame an ongoing debate among muny players: which is hardest, Eastmoreland or the Great Blue at Heron Lakes? If you don't like tree problems, head for the Great Blue!

In 1917, the Ladd Estate Company gave the Portland Parks & Recreation Department 160 acres of property, in the hope that public use of the land would draw attention to the new homes for sale in the area. H. Chandler Egan of Medford was commissioned to design a golf course on the property, and a self-supporting golf system was born that has survived into present times. Today, looking at Eastmoreland Golf Course and the stately surrounding neighborhood, it's difficult to say which turned out more beautifully.

O R E G O N G O L F

National experts consistently place Eastmoreland in the top seventy-five, fifty, even twenty-five public courses in America. It features more varieties of trees than many northwest arboretums, demanding golf holes, and a back nine that includes lakes fed by natural springs, and is bordered by the city's Crystal Springs Rhododendron Garden. Few holes this side of Augusta are as enticing in spring as the par-3 17th, played over sparkling Crystal Springs Lake, which mirrors big blooming rhododendrons of nearly every imaginable color.

Walter Hagen once declared the par-5 13th hole, at just 466 yards, to be either the best or the hardest par-5 he'd ever played, depending on

There is flat out no better finishing hole than number eighteen on the Great Blue Course at Portland's Heron Lakes. Par or better here and it doesn't matter what kind of a mess you made of the rest of this very difficult course—you will be back.

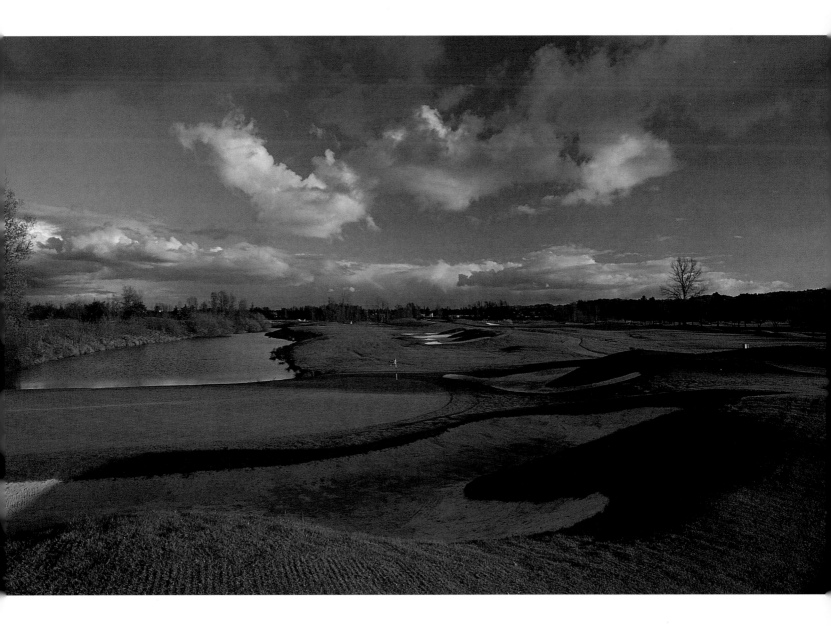

One of the most welcoming signs . . . in life.

which version of the story you believe. Eastmoreland is a national treasure, as golfers who have come for such events as the National Public Links or World Masters Games tournaments can attest.

Completing the city's golfing amenities are the two courses at Heron Lakes in north Portland, Greenback and Great Blue: both named for types of herons, their most enduring residents. They were built on land that used to be occupied by Oregon's second most populous city, Vanport, home to thousands of wartime shipyard workers before it was destroyed by a flood in 1948.

The Greenback course is more straightforward than the Great Blue, a dastardly links affair, which serious local golfers love to tackle. Both are the work of Robert Trent Jones, Jr., and both are also perennially ranked in America's best one hundred or seventy-five public courses.

Some regulars like to play the Greenback, with its less difficult holes and fewer fairway bunkers, as a warm up to or relief from the Great Blue, which is my favorite of the city courses because it requires absolute concentration. The Great Blue's narrow fairways, ample water, and tall rough areas demand course management for the entire eighteen holes.

Some of my favorite rounds ever were played on this course with the late Pokey Allen, then the colorful football coach at Portland State University. We'd meet at dawn on summer mornings a couple of times a week to bat the ball around, often stopping along the way to visit with my sons. During their college years, three of them worked on the Heron Lakes greens crew.

One morning found us leaving the 3rd tee after Pokey had just pulled a drive deep hard left, and shouted for maybe the millionth time to the empty golf course, "There is no justice!"

My second son, Jason, was riding a small tractor nearby, raking a fairway bunker. "Looks like fun," I called out.

"Hop on and try it, Dad," Jason responded.

When I hesitated, Jason—the free spirit of the family—told me that whenever a golfer makes a comment similar to mine, he invites them to take a ride.

O R E G O N G O L F

"Probably not in the city's best interest," I advised.

"Probably more fun than golf," Pokey added.

I won't tell you whether we rode that tractor, but after laughs all around we played on in the early morning sun. Pokey died of cancer a scant few years later, and I can bear to lose such a great partner only if I believe he's holding a tee-time for us up at Paradise Lakes.

About the Great Blue, though: While some loathe its difficulty and avoid playing it, the dedicated player not only recognizes the challenge but realizes that if you can play there, you can play anywhere. So, what the heck, load up some extra balls, enjoy the herons and the views of Mount Hood, and take a swing at it. And if you need to, it's acceptable to occasionally lament aloud the injustice of the course.

Taken as a whole, it would be hard to find a municipal system anywhere that has a better assortment of courses than Portland's. "We don't

Morning fog greets a solitary golfer at Rose City Golf Course, the second oldest municipal course in Portland. Play began here in the Spring of 1922, but was stopped temporarily that summer due to "long grass and no mower."

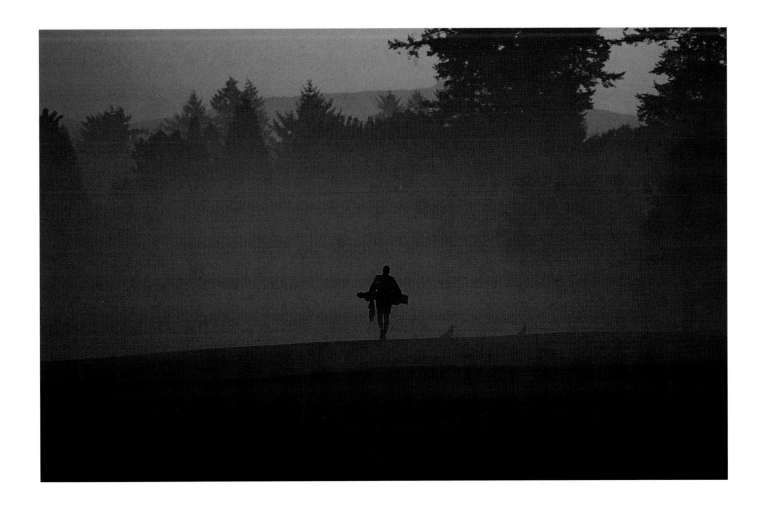

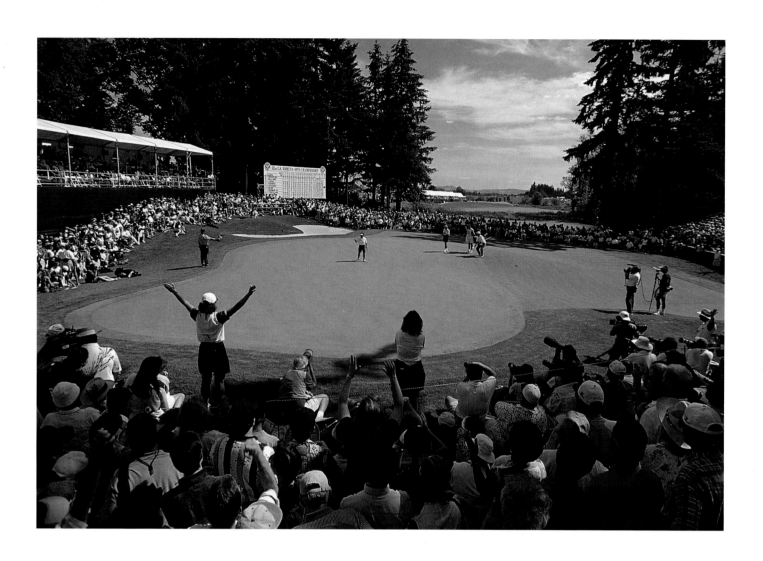

▼ *Where dreams of playing the tour begin for girls and boys.*

have the best weather, and maybe not as many courses per capita as other states, but our goal is to provide access to good golf at a reasonable price," explains golf director Zoller. "When you can do that and half your courses make the top seventy-five, you're doing something right."

Other popular public courses in the Portland metro area include Broadmoor (which opened in 1931, when six sisters decided to transform their parents' dairy farm into a golf course) and, in the same northeast Portland area, Colwood National, long known as one of a very few courses in the northern climes that never enforces a frost delay. Golfers in winter go off regardless of ground conditions, and the fairways and greens never seem the poorer for it.

Also among the city's unique venues is the Children's Course. Located to the east, in the suburb of Gladstone, this executive-length

O R E G O N G O L F

track was purchased by Portland businessman Duncan Campbell and his colleagues to provide kids—especially those living in the inner city—access to the greatest of all games. It's open to the general public and is an excellent place for children to learn to golf.

Teachers here include volunteers such as former baseball player Artie Wilson, a Negro League Hall-of-Famer; Portland pro Larry Aspenson; and local parents. The LPGA's highly successful inner city golf program is also located here, under the direction of another longtime local professional, Marti Loeb. The program teaches thousands of children how to chip and putt, and instills in them respect for one another and for the game's rules.

"We tell them golf is the only sport where you're the referee," Marti says. "It's integrity based, and the kids really take to that."

It's great to watch the youngsters play, and even better to do so while getting in a quick nine with the ebullient Artie Wilson, who, at seventy-nine, is still a tough competitor and wonderful storyteller. "Satchel Paige is the best pitcher I ever faced," Artie's been heard to advise his foursome before putting, "but you should have seen Willie Mays's dad play. Now *he* was something!"

Travel outside of Portland's core area, twenty-five minutes in any direction, and you'll find an abundance of additional good courses for golfers at any level. To the west is the much-heralded Pumpkin Ridge, home to a pair of courses. When they opened in 1986, national reviewers named them the best new public and the best new private courses in America. (Where else has that ever happened in one place?) Pumpkin Ridge also gained national attention when Tiger Woods won his third consecutive U.S. Amateur Championship there in 1996, a first in amateur golf, and for being the site of the hugely successful 1997 U.S. Women's Open.

Though it only recently arrived on the scene, "the Ridge" seems to fit the rolling farmland that surrounds it. Almost every one of its thirty-six holes looks like it's been a part of the landscape forever. The Witch Hollow course is private, the Ghost Creek public, with Ghost Creek now serving as home to numerous corporate and charity events.

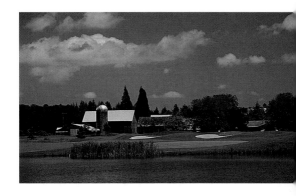

◄ *Golf fans by the thousands converged on Pumpkin Ridge, west of Portland, two summers running, for the U.S. Amateur in 1996 and the Women's Open in 1997, both proving to be hugely popular events with galleries. The 18th green of the complex's private course, Witch Hollow, allowed players a stadium-like finish.*

▲ *Once farmland itself, Quail Valley Golf Course, near the town of Banks in Washington County, gives visitors bucolic views of a farmstead next door and vineyards on nearby hills.*

▼ *Putting around at Island Greens, a perfect family introduction to the game.*

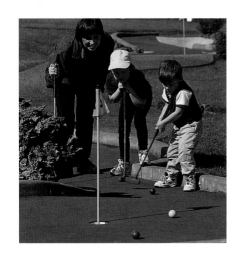

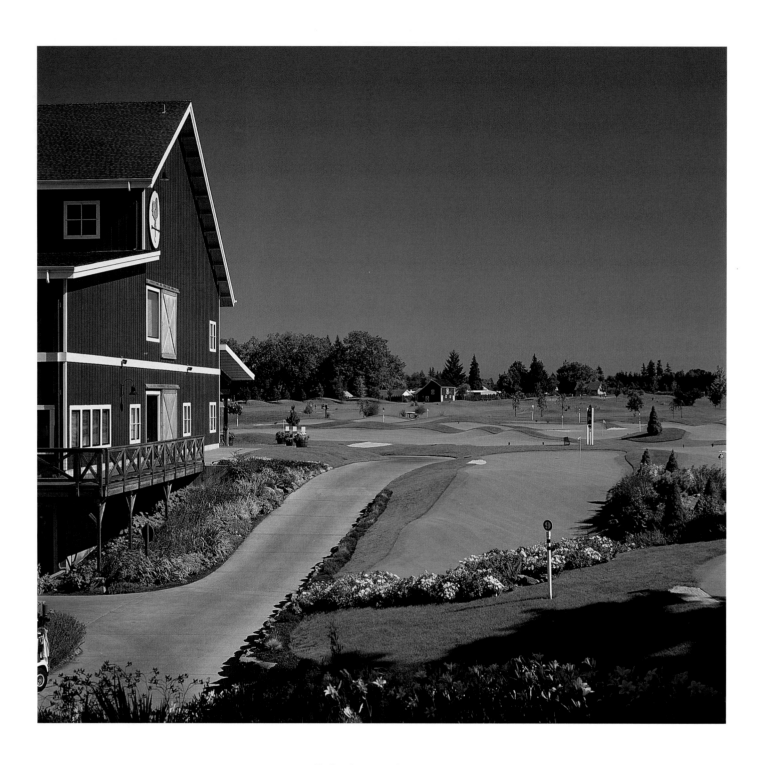

With Oregonians' sensitivity to growth and development in mind, owners of Langdon Farms Golf Club, south of Portland, wanted their clubhouse to blend in with the surrounding farming community.

Still farther to the west, near the community of Banks, locals take to the public Quail Valley Golf Course, another farmland beauty, constructed within view of some of the region's top wineries. It's backers—Portland golf director Zoller is the designer—claim that the average golfer is capable of making par or birdie on every hole of this 6,600-yard layout, a course designed for fun play.

Located south of Portland, between the I-5 freeway and Highway 99, Langdon Farms is so well designed that golfers hardly notice either busy thoroughfare. They do notice a clubhouse that looks like a massive, contemporary barn, and if they take a cart, they'll ride through a smaller barn on the 8th hole. I enjoy this well-maintained course, with its creative mounding and links feel, and I'm actually tempted to use a cart here just to ride through that little barn and the actual working farm situated just before it.

Oregon's newest thirty-six-hole facility, the Reserve Vineyards and Golf Club, offers two outstanding championship courses near Aloha, one private and one public, with those designations alternating bimonthly to allow play on both courses by all comers.

The Reserve is also the latest home of Peter Jacobsen's Fred Meyer Challenge and already a winning locale among galleries and players alike. The Challenge, by the way, has been Jacobsen's vehicle for giving back to local charities almost the same amount of money he has earned in his career. Each fall, the event brings the world's best professional players to town for a hugely popular team event that knowledgeable local fans prefer to a regular Tour tournament.

Designed by John Fought and Bob Cupp, the Fought course is a traditional beauty with plenty of sand and no shortage of ups and downs. The Cupp design is of a more contemporary style, open with plentiful water. This design team also gave us Crosswater in Sunriver, and Pumpkin Ridge, and little more need be said. Fought and Cupp create courses you just want to experience.

Travel east of Portland to the town of Gresham to find Persimmon Country Club, a semiprivate course whose mountain views from rolling fairways are among the most stunning in the Portland area. I love this place, if for no other reason, because I hit my longest career drive here—an honest 356 yards, as confirmed by my playing partners. Okay, the ball did get quite a bounce from a downhill cart path, but I don't care—I'll always love Persimmon.

The view from nearly every tee box at the private Oregon Golf

Two relative newcomers to the Portland-area golf scene, Langdon Farms (above) and the Reserve Vinyards and Golf Club (below), were both designed by the award-winning architect team of John Fought and Robert Cupp.

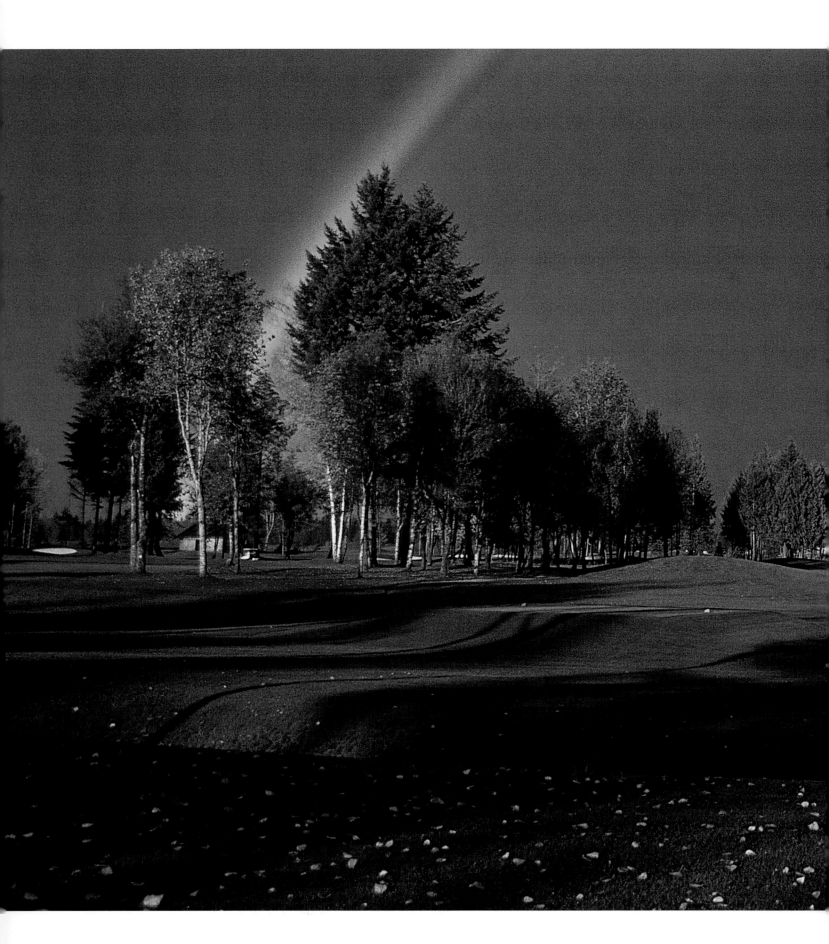

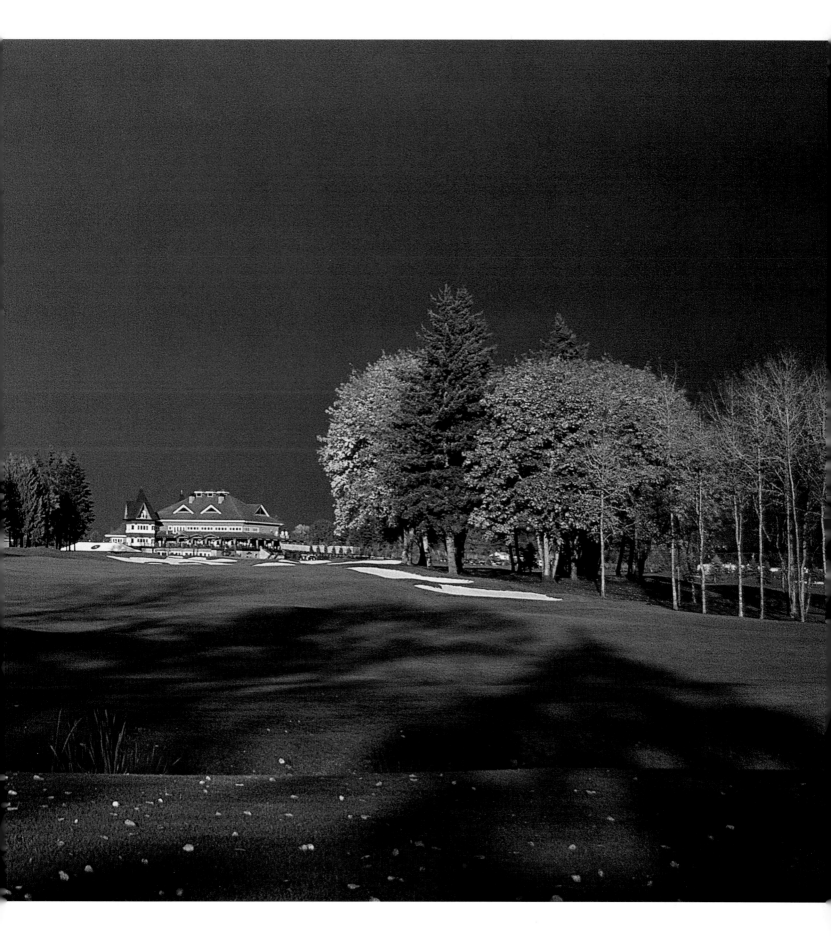

O R E G O N G O L F

Club—located near West Linn, high above the Willamette River on a bluff known as Pete's Mountain—is apt to take your breath away before you remove a club from your bag. The course travels steep terrain, its holes dropping drastically or rising precipitously. Each one would be a visual treat even if the Cascades didn't stand on the distant horizon and the Willamette didn't run hundreds of feet below.

But many of the city's other private clubs are every bit as dazzling. Waverley Country Club on the Willamette River southeast of the city is one of the Northwest's oldest, its original course built in 1896, a traditional beauty whose entryway rivals Magnolia Drive at Augusta National. Proceed past the exquisite homes that line this narrow drive to arrive at the most stately clubhouse setting in town—a proud, white building reminiscent of the old south.

This place is about tradition—the course has never been modernized—although there have been a few unusual moments along the way. During a break from his successful run for the title at the U.S. Junior Amateur tournament staged at Waverley in 1993, Tiger Woods won a long drive contest by rocketing a ball clean across the Willamette River. ("And he wasn't even wearing golf shoes at the time," marveled one onlooker.)

In the northeast part of the city, two old-line clubs are all but neighbors near Portland International Airport. Riverside Golf and Country Club offers a challenging yet walkable layout, and a membership whose friendliness is best enjoyed over a pre-round lunch in the clubhouse, where two fresh turkeys are roasted every day of the year.

But for serious competition, nearby Columbia Edgewater is reputed to have the most low handicappers of any single club in the United States. While this may be debatable, it is a fact that only two clubs in U.S. golf history have ever placed two players on the same Walker Cup team, the highest level of amateur competition. Columbia Edgewater did it with Bruce Cudd and Dick Yost; Eastlake in Atlanta once sent a pair named Watts Gunn and Bobby Jones, Jr.

And that's a bit of history, like much of Portland's golf lore, that a city's golfers can be proud of, no matter what course they play.

◄◄ The old admonition, used virtually everywhere, is if you don't like the weather, wait five minutes and it will change. But only in Oregon, at courses like the Reserve in Aloha, can golfers encounter all weather conditions at the same time.

◄ The inviting 10th tee at Portland's Columbia Edgewater Country Club isn't at the edge of any water at all. Before being destroyed by fire, C-E's clubhouse was located across Marine Drive, next to the Columbia River. Now players visit the perfectly groomed Northwest classic without ever seeing the mighty Columbia.

▲ The men's locker room at Oregon Golf Club, distinctively Northwestern.

SAND on the RIGHT

In 1996, Sunriver, the first major Northwest resort dedicated primarily to golf, opened Crosswater, its third course and most spectacular to date. The national media reviewed the course: one publication declared it the single best course in the Northwest, and another went even further, concluding that there likely isn't a more beautiful or better-conditioned golf course anywhere.

It's hard to disagree. Crosswater occupies a prime piece of real estate in Central Oregon. Offering a whopping 7,683 yards

◄◄ *By every measure, Sunriver's Crosswater is a great golf course; it's sheer beauty is nearly overwhelming. But developers spent as much time on environmental concerns as aesthetics, going so far as to actually increase the runoff of water in several places to make surrounding wetlands even more healthy. Oregon's Department of Fish and Wildlife was also consulted on how to improve and maintain fish habitat. The result: more than two hundred acres of surrounding meadows, lakes, and forests and miles of Deschutes and Little Deschutes river frontage remain untouched.*

◄ *Oregon is an environmental leader in golf, with numerous courses designated Certified Audubon Sanctuary Courses. Aspen Lakes, near Sisters, is certified as an Audubon Signature Course.*

from the tips, and with unmatched views of the Cascade Range and two dazzling rivers threading their way through the layout—you *will* cross water here, seven times!—its beauty is matched only by its difficulty. But regulars point out that with five sets of tees, anyone can play Crosswater. And they will want to, repeatedly, once they've seen this perfect, sun-drenched place.

Sunriver's other two courses have established themselves as two of the finest resort layouts in the country. The Woodlands, with its bordering ponderosas and isolated fairways, may be the most popular golf venue in Central Oregon, on the basis of rounds per day.

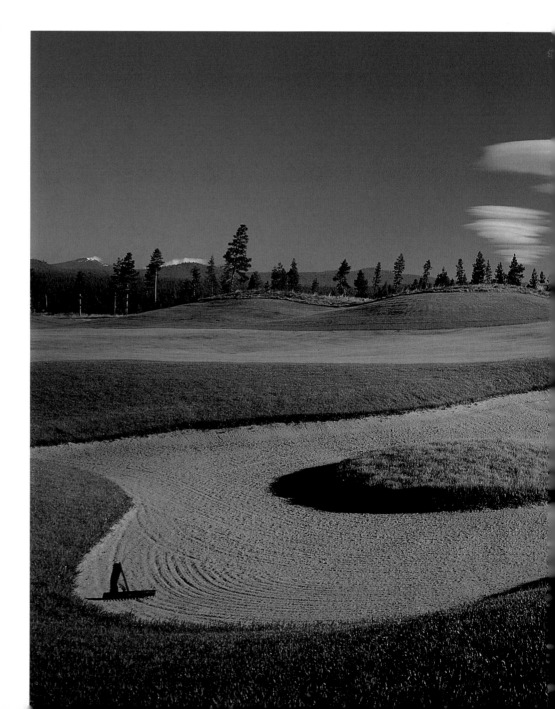

The older Meadows course, which begins at Sunriver Lodge and is better known to longtime visitors as "the South Course," has become a beloved favorite of vacationing families. In fact, our sons and their friends played some of their first golf here. When redesigning the course in 1998, operators reorganized the similarities between this high-desert Oregon course and the classic courses of the Southeast—flat land, sandy soil, and tall pines—and set out to make it a western version of North Carolina's Pinehurst #2, considered by many to be the granddaddy of all American golf courses.

"We talked to a lot of people who come here," said Jimmie Griffin,

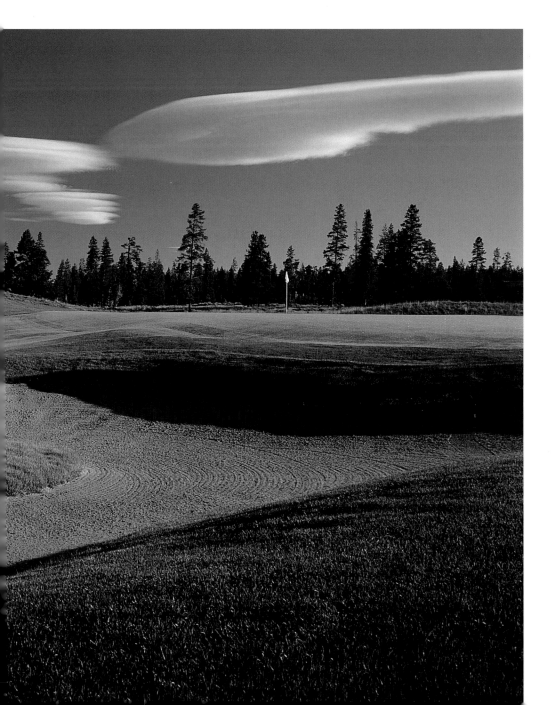

Crosswater's designer, Robert Cupp, has worked on hundreds of courses in as many locations, but says this site is one of the most magnificent he's ever encountered. Nearly 45 percent of the full resort's total acreage has been preserved as open space.

who oversaw the project for the Bob Cupp–John Fought design team, "and we learned how many of them were endeared to this course. A lot of folks have a lot of years here, playing with their kids and teaching them the game and all. They have strong feelings about the golf course."

So the trick was to improve the layout and upgrade the irrigation system without taking away what longtime visitors liked about their experience with high-desert golf. Even regulars should be pleased with the changes, since an excellent layout became even better, with such Donald Ross design techniques as sand traps that guard the fronts of greens but become invisible when players on the putting surface look back toward the fairway.

While Crosswater is private and open to guests of the resort, the Woodlands and the Meadows are available to the daily fee player, and all three welcome golfers who prefer to walk. As a group, these courses represent resort golf at its finest and offer the average golfer an intriguing plus. At 4,100 feet above sea level, the ball will travel higher and farther. So go ahead and use your 7 iron from 170 yards, just like the guys you see playing the PGA Tour on television.

The region's other hugely popular resort is Black Butte Ranch, which offers two gorgeous courses northwest of the town of Sisters. These courses have more of a high-country forest feeling than other Central Oregon layouts, which tend to embrace the desert. Both Big Meadow and Glaze Meadow let the visitor drink deep of vivid Central Oregon color, from the abundant green hues of the fairways and the pine forests from which they were carved, to breathtakingly blue skies high above land once known only to trappers and cattlemen. Sparkling white sand traps, and the distant snowcapped mountains that range in and out of view, are in stark contrast to the varied dark shades of Black Butte itself, a nearby sentinel overlooking both eighteens.

It was our good fortune to play these courses with two young golfers whose contrasting perspectives of Black Butte golf were as divergent as the golf holes themselves, only two of which run parallel. Andy Carmichael, a college student, grew up in his family's home on the

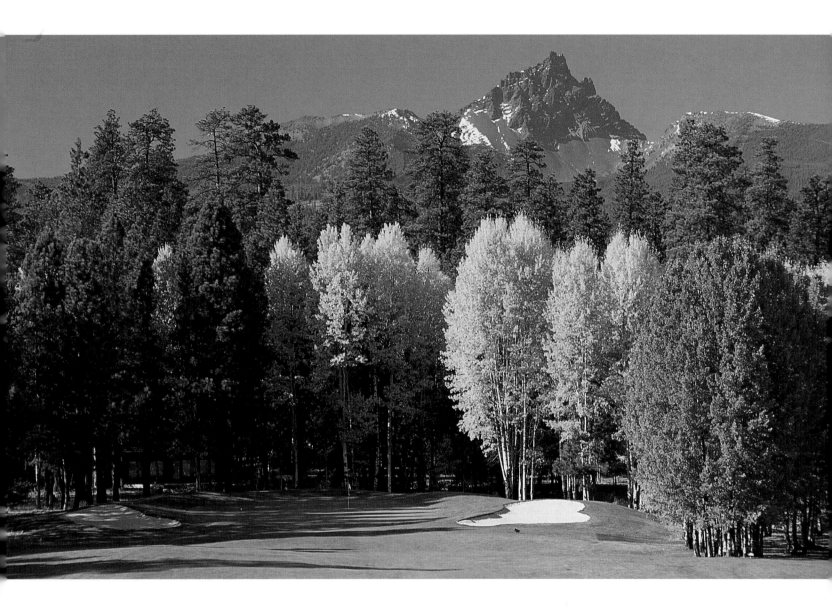

7th hole at Glaze Meadow, assuming that this was what golf was like everywhere. Shawna Nelson, an assistant pro, is from Brookings, Oregon, where there were no golf courses.

When Andy left for college in Salem and played his first public courses, some of them adjacent to freeways and commercial development, he was absolutely startled. "Wow!" he recalls thinking. "Those courses at home are pretty good." Now when he returns to Black Butte, Andy looks forward to playing the back nine of Big Meadow, where "each hole is a world by itself—you can't see other homes or anything."

Shawna Nelson's first experience with golf came when she attended community college in Eugene and worked at Fiddler's Green, a thriving

The aspens at Black Butte Ranch are blessed with an even more glorious backdrop, the Cascade Range, some of whose peaks are distinctive in appearance and name, such as Three Finger Jack.

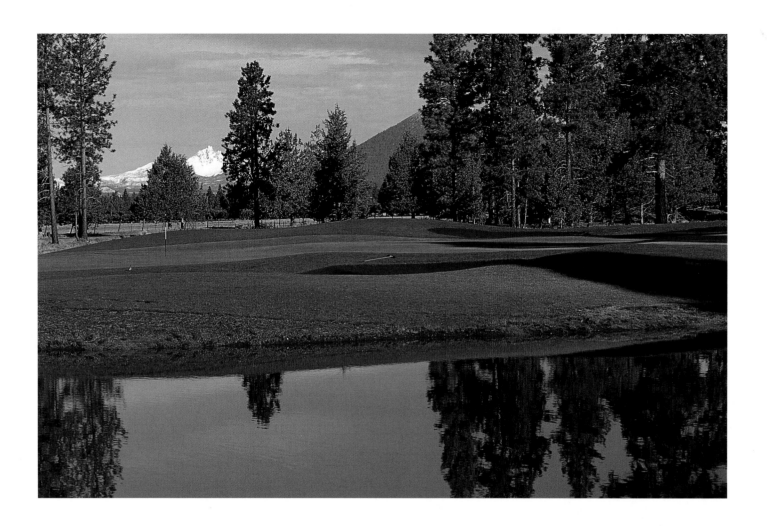

▲ *Aspen Lakes is one of few golf courses anywhere where players never need wonder if their shot has found a sandtrap: a white ball in a red bunker is visible for hundreds of yards.*

▶ *The remarkable, 25,000-square-foot clubhouse at Broken Top not only appears to be growing out of the ground, it was literally built upon the existing boulders of an old pumice mining site. "It has good bones," CEO Mary Arnstad told the local Bend Bulletin newspaper. "Time will be its friend."*

retail center and heavily played par-3 course spread over flat farmland. That was her take on the game, before she got a summer job at Black Butte and was overwhelmed with its mesmerizing beauty.

"It was just amazing seeing all the mountains," she said. "And it's all so peaceful. That's what I like most about it."

Andy plans to be a history teacher, and Shawna is working to become a golf professional. Both mirror the reactions of most golfers who play Central Oregon, newcomers and the veterans of many sunny rounds alike. It's such a joy to be on these courses and in such beautiful surroundings, that where you started or how you play become forgotten in the process of experiencing Black Butte.

The newest addition to public golf in the Sisters area is the twenty-seven-hole Aspen Lakes. Its three nines are named, "Faith," "Hope," and "Charity," after the peaks of the nearby Three Sisters. Aspen Lakes

also features red sand bunkers, which give its immaculate fairways a distinctive look.

But it's the Bend area that still serves as the focal point of the region for golf. Bend has nearly thirty courses, virtually all of them worthy of play, and Chamber of Commerce types have taken to calling their town "the Palm Springs of Oregon."

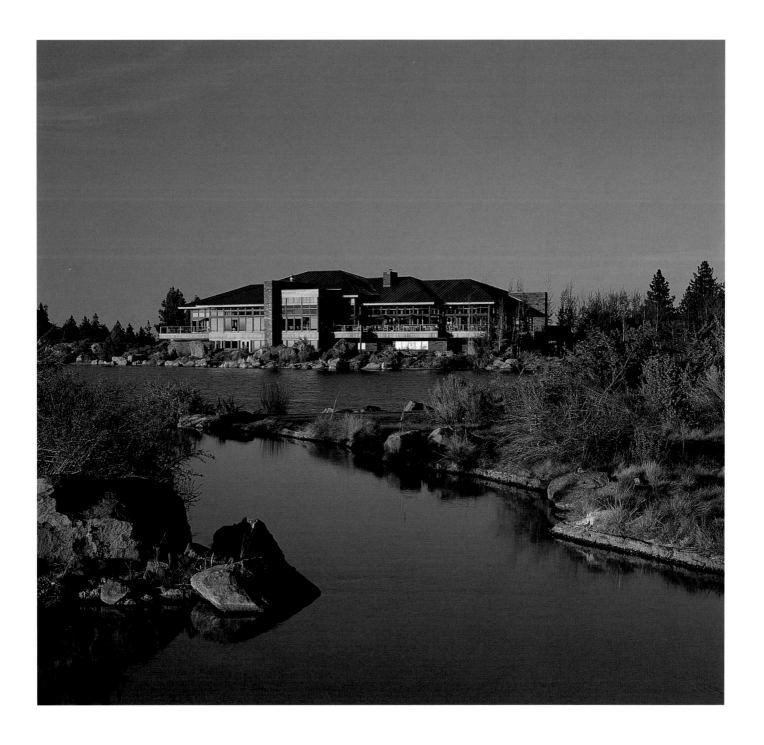

▲ *Fairways flow alongside the tumbling tumbleweeds at River's Edge Golf Course in Bend, a hallmark of golf in Central Oregon.*
▶ *Recreationists head for the powder of nearby Mount Bachelor in winter, and to the Ponderosa Pines of Widgi Creek Golf Course, just down the hill from the mountain, during summer months.*

We enjoyed Bend's Mountain High because of its fine grooming. If you ask my wife, Vicki, the pure fun of trying to hit the island green on the par-3 5th hole is an added attraction. She enthusiastically embraces the challenge each time, and frequently succeeds in sending her ball over the water and landing it on the grass.

River's Edge, right in the heart of town, offers challenging target golf, with repeated risk and reward opportunities over hillside terrain. To the south, in LaPine, Quail Run offers the best economic value in the area along with a nicely maintained nine holes.

Perhaps the most carefree golf I've played has been at an executive course only minutes from Bend proper, named Orion Greens. On family vacations we'd let our four boys swing away on this neat little track, and they always seemed to enjoy riding in imitation Rolls Royce golf carts. For me it was relaxed golf, during which I got to observe my children take to the game I love and to appreciate Vicki's natural swing (which she doesn't believe she has). All of this was removed, say, from the unnecessary anxiety of Saturday morning Nassaus with regular partners back home. For me, Orion Greens is vacation golf at its best.

With so many appealing courses to choose from, it's nearly impossible to make comparisons, but in recent years the most spectacular golf development in the region has taken place on the road from Bend to the ski areas of Mount Bachelor. Included among the wonderful assortment is Widgi Creek, a semiprivate gem that sits next to the Inn at the Seventh Mountain Resort and borders the Deschutes National Forest. This well-maintained course is resplendent with eleven lakes and fun, narrow fairways.

Nearby Awbrey Glen Golf Club is private and covers some of the most hilly terrain in the area, but this spectacular Bunny Mason design is a joy to play. The signature hole here, number 13, is indeed unforgettable. It's a 190-yard, par-3 that runs up a little draw to a green surrounded by tall, brown lava rock walls. Even the trap, which guards the green on the right, is host to an outsized lava boulder. The chances of a hole-in-one here must surely increase as balls fortuitously careen off the walls of the box canyon.

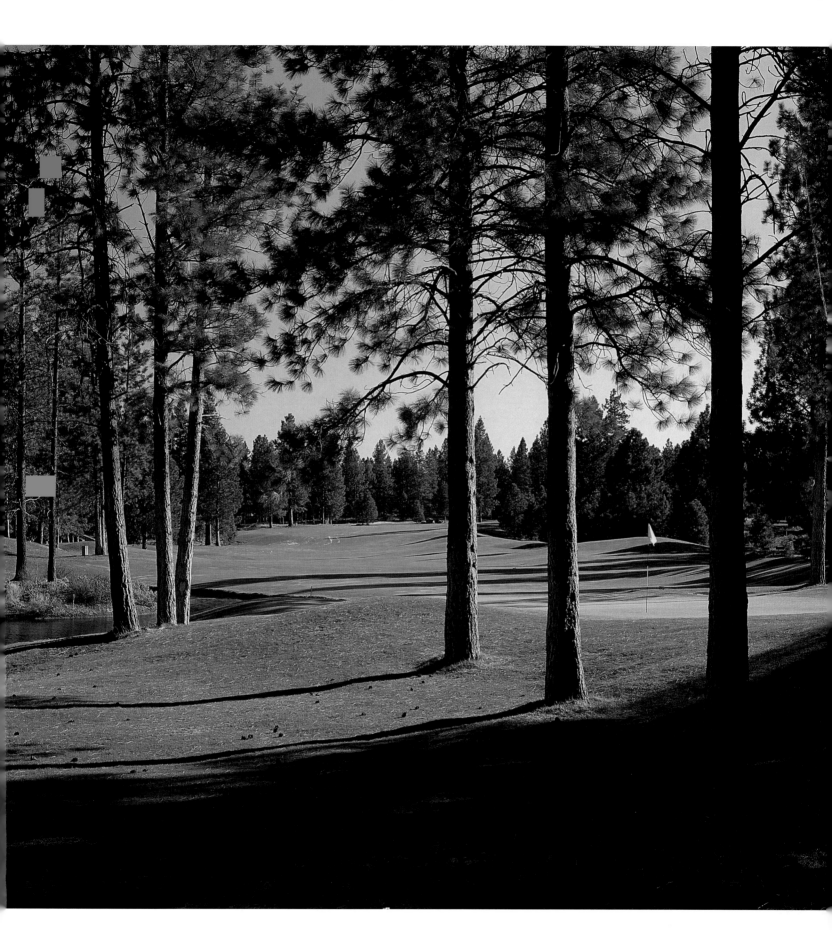

Yet another Bend-area private, Broken Top, named for the nearby peak, is an inviting, upscale development. Former tour professional Tom Weiskopf and partner Jay Moorish dreamed up this gem, with its Frank Lloyd Wright–inspired clubhouse, striking elevated tees and greens, and picture-perfect fairways, punctuated in places by lava outcroppings. Though Weiskopf, who won the British Open in 1973, has helped to design forty courses around the world, he told the local paper, the *Bend Bulletin,* that few of them matched Broken Top.

My son Ryan and I played Broken Top with residents Kirk Bashore, a retired banker, and Mike Young, a former airline pilot. Both hail originally from Hollywood, California, and now live next door to each other overlooking the golf course, minutes away from the thriving downtown community in Bend. Few places allow such an appealing lifestyle, as Kirk and Mike readily acknowledge.

"The good life," Mike called it. "It's more a community and less a resort," Kirk added. "You get to know your neighbors because they live here."

Located in what is now a virtual golf mecca, Bend Country Club, opened in 1925, was only the second golf course built in Central Oregon. The first, Central Oregon Golf Club, is no longer in existence.

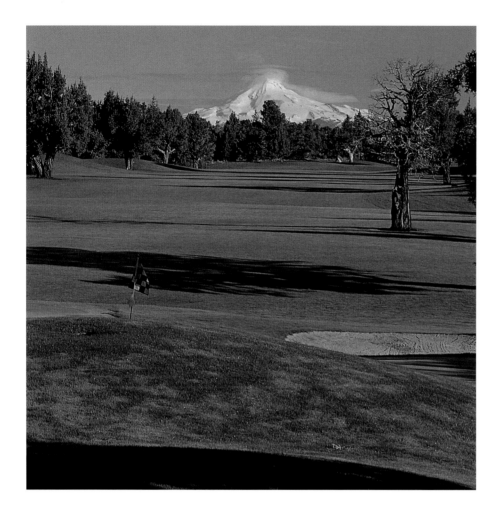

The Eagle Crest Resort offers two eighteen-hole championship courses, a new eighteen-hole putting course (featuring the 145-foot "pit of despair"), and breathtaking views of the Cascades.

Not all of the courses in Bend are products of the relatively recent golf boom. Bend Golf and Country Club is a classic charmer dating back to 1925. These days, members play temporary greens when necessary during the winter, but longtime players remember the adventurous practice of negotiating the course backward during weather months, hitting from temporary tees and using the permanent tees as greens. Play Bend in either direction, with its towering ponderosas, and you'll enjoy one of the outstanding golf courses of the Pacific Northwest.

About fifteen miles to the north, the town of Redmond has earned a prized place on Oregon's golf map. Many Portland golfers claim the two courses at Eagle Crest Resort—often less crowded than either Sunriver or Black Butte—as their favorites. The older of the two, Eagle Crest, offers golf holes that are in canyons amidst junipers and lava flows, as well as stunning vistas of the Three Sisters and other Cascade peaks.

With it's neighboring plateaus, tree-lined fairways, and diminutive greens, the Prineville Golf and Country Club is a traditional, tough test of golf. The course record, a remarkable 58, is held by well-known Northwest pro, Pat Fitzsimons.

The newer Eagle Ridge feels more open, like a desert course with ups and downs, replete with fields of wildflowers joining the sage scrub that borders the fairways. Both were developed by the Jeld-Wen Corporation of Klamath Falls, the same outfit that is behind the newer Running Y Ranch in its hometown. Also, both Eagle Ridge and Eagle Crest have perhaps the fastest greens in Central Oregon. I discovered this firsthand on the 1st hole of the Eagle Crest course, when a 15-foot birdie putt quickly became a 20-foot par putt. But not to worry. These bentgrass beauties are as true as they are quick: shorten the stroke, get them on line, and you're bound to make more putts than usual.

If there's a sleeper locale when it comes to golf in this part of Oregon, you'll find it twenty miles east of Redmond in Prineville, a small timber community with just under seven thousand residents. It's hard to imagine that any other town of that size has two more-remarkable golf courses, or a better municipal course.

For character, you can't match Prineville Country Club, located about three miles east of the town proper and laid out fifty years ago by Portland professionals Eddie and Bob Hogan, Ted Longworth, and Larry Lamberger, Sr. It's an elegantly maintained, rolling nine-holer surrounded by farmland and nestled against juniper hillsides. It's also said to be the last home of the legendary "giant Oregon beaver," reputed to grow up to five feet in length (and made famous by author Gail Ontko).

The course is better known for its traditional feeling and small, treacherous greens, which each year lure the top pros from throughout the Northwest back for the Prineville Pro-Am and Invitational. With the average winning score over the years at one under par on an eighteen-hole course that plays under 6,000 yards, it is little wonder that the winner's list reads like a Who's Who of Oregon golf: Bob Duden, Bill Eggers, Jerry Mowlds, Bunny Mason, Harvey Hixson, Tom Liljeholm, Tim Berg, and Byron Wood.

To do well at Prineville you have to play old-time golf, where length buys you nothing, and a premium is placed on accurate irons and a sound putting stroke. We liked Prineville County Club immensely, after we were shown the way by resident pro Tom Brown—heralded locally for strapping on his waders and lashing down course bridges when Ochoco Creek flooded its banks—and member Tom McDonald, a wood products consultant. McDonald's home is adjacent to the course, and he goes to work each morning in his home office wearing his golf shoes. When he can't stand it anymore, he goes outside and plays.

If this private little wonder represents the best of golf from an earlier day, its contemporary counterpart resides a few miles back toward town at Meadow Lakes Golf Course. We'd read in one of the regional guides that the course was built for the recreation of residents and visitors, but that is not so.

"Nope," said city manager Henry Hartley, "Meadow Lakes is a waste-water treatment site, without a doubt. It might be the best one I've ever seen, but that's what it is."

The land on which Meadow Lakes was built nearly became an alfalfa

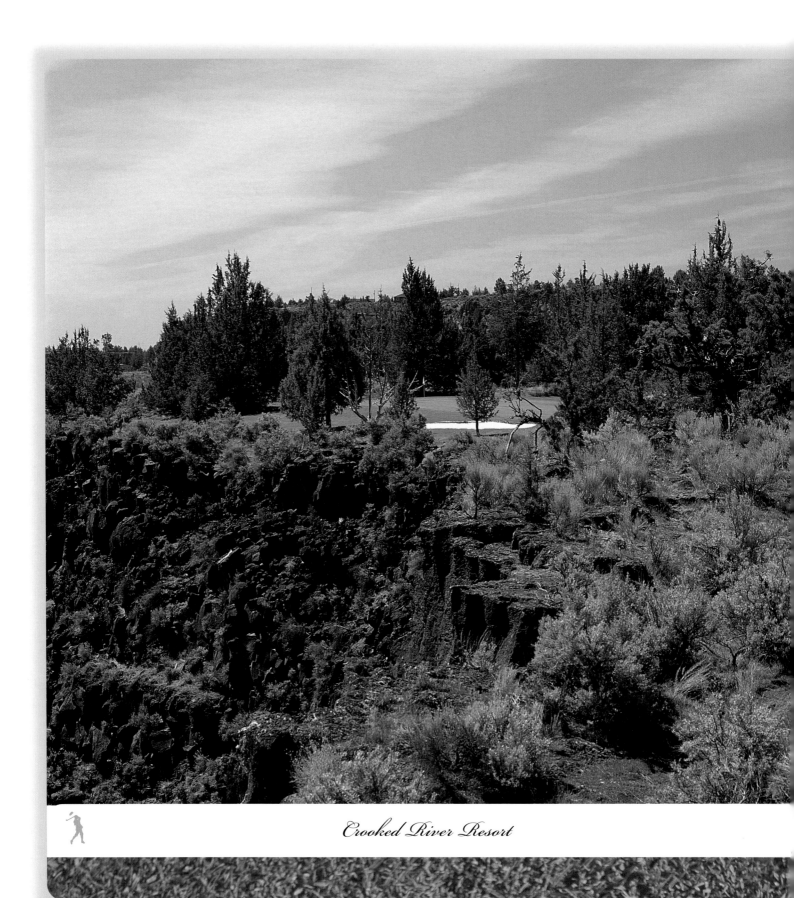

Crooked River Resort

The Most Spectacular Golf Hole in Oregon

It's all but impossible for the average Oregon golfer to select one course as a favorite. How is one to choose from such tantalizing variety: The parklands of Portland or the linksland of the coast? Lush, green valley venues or arid, high-desert beauties? So the tendency is to pick favorites by region: of all the good courses in Central Oregon, for example, Crosswater is a runaway favorite.

But selecting a favorite hole is quite another thing. Here, a judgment can be made by a few simple measures: Is the hole spectacular to look at? Does it offer a special challenge each time it's played? And, most important, does the golfer generally play it well?

My clear favorite, on all counts, can be found in an unlikely place—Crooked River Ranch, a quirky little community and vacation mecca north of Redmond. The golf course itself is fun and user friendly. Relatively open and plenty scenic, most of its holes are not overly taxing but present the advanced player with the opportunity to go for low numbers via a little risk and reward.

The ultimate invitation is extended at the 5th hole. A hard dogleg left, it plays only 260 yards. Look straight from the tee, away from the dogleg, and the fairway appears an easy target—a couple of 5 irons over this short distance and you're putting for birdie.

But looking to the left, the player takes in a scene that could easily qualify for one of those "world's most difficult

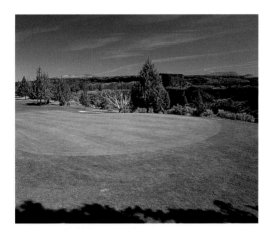

Those who've negotiated this dogleg claim it's best to play it straight—directly over the Crooked River Canyon.

golf holes" calendars. Only this one is real.

The fairway is bordered left by the Crooked River Canyon, at three hundred feet deep surely the greatest chasm in golf. The green, a bright speck out there in the distance on the right edge of the canyon rim, is a lonely, emerald island in a sea of brown, tucked within sagebrush and juniper trees, and guarded in front by sand. Oh, it's reachable with even a 3 wood if one cuts across the dogleg, but making the attempt means sending your ball out over vast, empty space. To see it is to want to go for it.

Before doing so, some players are compelled to momentarily forget the hole and hit an old ball directly across the canyon purely for the fun of it, and most likely to the consternation of the adjacent landowners and environmentalists.

"Everyone does that," laughs Gary Popp, Crooked River's former longtime pro. I think there must be five hundred of my range balls over there." Popp estimates the carry to be approximately the same as when the player goes for the green from the back tee, but arguably more thrilling because the ball is actually in play.

Newcomers are best advised to save themselves for the swing that counts. First, drink in the view of the wild river below while waiting for the green to clear. Then step up and swing away at one of the most spectacular challenges in the game of golf.

For the best view of a beautiful golf course
water treatment site, visit nearby Ochoco
Viewpoint. If you've already played
eighteen, it's okay to drive to the top.

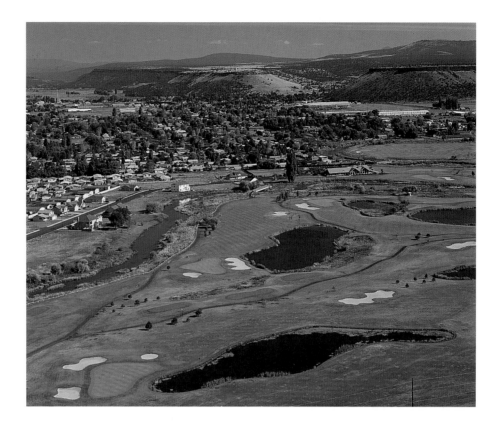

field. That's what the Environmental Protection Agency originally suggested the town use as a leaching field, after threatening Prineville with fines of up to $25,000 a day unless it stopped dumping treated wastewater into the nearby Crooked River. The golf course was Hartley's idea, and because it would prove more cost effective and would require 240 acres less land than the alfalfa, its construction was ultimately aided by a $2.5 million grant from the federal government.

The course opened in 1993, studded with ten evaporation lakes and luxurious fairways that readily accept 600,000 gallons of treated wastewater daily. Water hazards never served so expeditiously.

"Henry and I like to joke that everything about golf is backward in Prineville," says head pro Jay Kinzel. "We use grass that was made to take a lot of water, not sun, the opposite of every other course in Central Oregon. And putts here never break as much as you think they should."

"Unless you hit them too hard," laughs Hartley, who still seems bemused by pulling off the golf course idea. "Then they break like crazy. It's just backward!"

O R E G O N G O L F

Kinzel and Hartley claim that the weather in Prineville is even better than in the rest of Central Oregon, a region that promises nearly three hundred days of sunshine a year, and that Meadow Lakes stays playable longer than other courses in winter. "And when our ponds freeze," adds Kinzel, "you don't have to worry about hitting into water."

We left Prineville impressed with what is largely an undiscovered golfing oasis, and marveling at how often in our travels the really special golf courses seemed to come in twos.

Getting there is half the fun. Hit the green on number sixteen at the Lost Tracks Golf Course near Bend, then take a stroll through the 1947 vintage dining car.

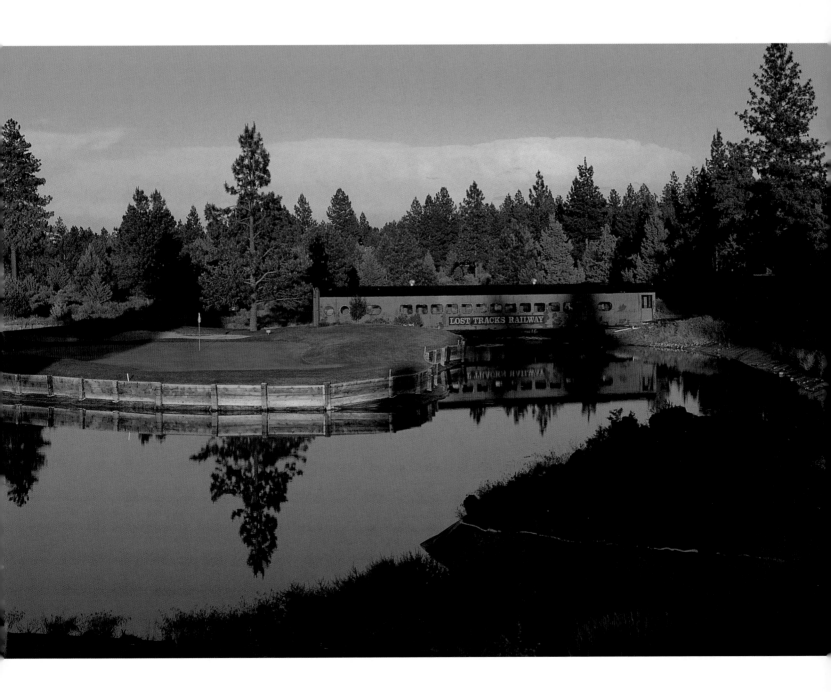

GETAWAYS

5

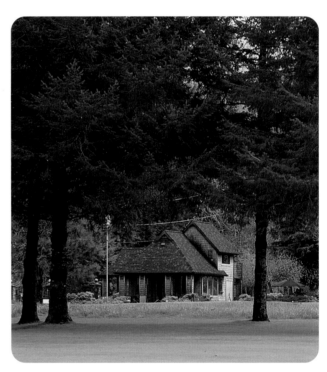

*M*ore than anything, golf can be pure escape. Play even half seriously and it's impossible to think about anything else, making the game particularly appealing to people who lead busy, stressful lives. Get to the golf course and life's issues seem to diminish with the pursuit of straight drives and holed putts. But travel to a course that's just a little out of town, and the escape seems absolute.

I learned this from my dad, who worked in the insurance business and seemed to talk about golfing more than he actually played. But he was happiest when he could go to a place in the

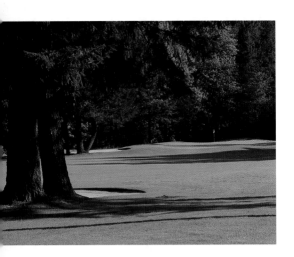

◄◄ *Located north of Gearhart, the Highlands is one of Oregon's nicest executive tracks, with flowers seemingly always in bloom around the clubhouse and in fairway beds and borders.*

◄ *Elkhorn Valley Golf Course was a lifelong labor of love for its late owner, Don Cutler, who fought with state agencies for a decade for the right to build it. Embracing the natural environment around it, the course is now operated by Cutler's family and is cherished by golfers throughout Oregon.*

▲ *Elkhorn, a nifty nine-holer, is only open from March through October.*

mountains only an hour east of Portland. When one of his insurance group or fraternal organizations scheduled a one-day tournament and picnic at Welches Golf Course, Dad was in heaven, each time declaring it the prettiest place on earth. That's a getaway course, and Oregon has more than its share.

Welches Golf Course has experienced many name changes over the decades, and exists today as the Resort at the Mountain, twenty-seven picture-pretty holes at the foot of Mount Hood. The newest owner has given the place a Scottish theme, pointing out that, after all, it is located in the "highlands" of Oregon. It is a scenic locale that remains a popular destination for Portlanders, many of whom go there under the guise of attending business conferences. Of the three nines at the Resort, Foxglove is the most challenging, with its holes lying in splendid forest isolation and many running adjacent to the rushing Salmon River. On the first hole, golfers are faced with a huge rock that stands smack in the middle of the fairway. During construction it was determined that the boulder was similar to an iceberg, three or four times larger underground than above and impossible to remove. The rock can easily be carried, yet gives the feeling that a mountain golf adventure is about to begin.

Two other venues are guaranteed to be at the top of any Oregon getaway list. Elkhorn Valley has been identified by some reviewers as the best nine-hole course in the Northwest and by others as the best in the United States. It rests in a mountain valley about two hours southeast of Portland and ten miles off Highway 22. Surrounded by wooded hillsides, Elkhorn is a little piece of heaven, the first course I know of in Oregon to use birdhouses as 150-yard markers, a touch that adds to the tranquility of the place. In the same category, eighteen-hole division, is Tokatee, the Jacobsens' college getaway course and the clear favorite of countless Oregonians and out-of-state visitors. Find it about fifty miles east of Eugene along the McKenzie River in the Cascades. *Golf Digest* magazine has named Tokatee among America's top twenty-five public courses and in the top ten of the most affordable. Juniors, for instance, pay five dollars for eighteen holes.

I played Tokatee with Bob Graves, a professional photographer from Portland; it was fall, and the autumn colors were resplendent. "The thing I like about Tokatee," said Bob, "is that there's nothing else to do here. It's beautiful, and it's just golf and that's all."

Still, Bob wandered off the fairway at times during our round to measure views he planned to photograph later. Others might prefer to pack a trout rod for visits to local streams between rounds, or to hole up with a book in one of the comfortable cottages and lodges nearby. Regardless, Tokatee offers great golf with challenging holes in a mountain setting. If you can't escape your worries here, you might as well quit trying.

Another course that's pure fun to visit is Indian Creek, located fifty miles east of Portland in Hood River, part of the Columbia River Gorge. The weather there is almost always above par, though often windy, as the world's best windsurfers can attest. Indian Creek wasn't designed by a professional architect, so there are some enjoyable, surprising holes. How about a par-5 with a ninety degree right turn, or a putting green with a two-foot-high ridge running through it? The original owners once told me they'd planned the course while sitting in lawn chairs, drinking beer, and drawing golf holes in the dirt with sticks. Getting local jurisdictions and adjacent landowners to accept the golf course wasn't easy, but these folks actually did!

Sometimes the most dramatic change in weather leads to the most satisfying golf escape. Many city dwellers travel to Central Oregon and the first golf course in the country owned by Native Americans.

Kah-Nee-Ta Resort's eighteen-hole course is located next to the Warm Springs River, and is operated by the Confederated Tribes of Warm Springs. This is Oregon at its rugged best, only two hours east of downtown Portland, yet a place where golfers may glimpse wild horses running in the sage-covered hills high above fairways.

Insiders also know that Kah-Nee-Ta is a destination where they can have a rain-free round of golf, a frequent compulsion for some during Oregon's rainy months. Kah-Nee-Ta guarantees more than three hundred days of sunshine a year, and those who visit the desert course each March

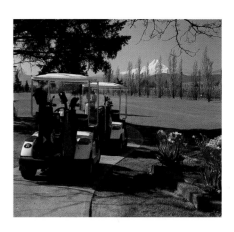

Hilly terrain has never frightened off the true golfer in Oregon, though it may make carts a little more compelling. Carts are available at the always-interesting Indian Creek Golf Course in Hood River, and most everywhere.

It's summer nearly year-round at Kah-Nee-Tah Resort, as the brown, high plains can attest.

for a season-opening pro-am tournament generally play in shirt sleeves and watch their shots bounce and roll on hard fairways. It's a well-kept secret that spring begins at Kah-Nee-Ta long before it does in town.

Our favorite coastal getaway spot is the Highlands, just north of Gearhart, the best-maintained executive course I've ever played. Vicki teases me because on nearly every visit I photograph its picturesque club-house, which is tucked among scores of flower boxes and blossoming plants in hanging baskets. Inside, owner Dan Strite, an affable golf curmudgeon who has operated the course for twenty years, greets players with equal amounts of charm and admonishment on the game of golf. Dan estimates that he hands out one thousand National Golf Foundation booklets on how to play and two thousand ball mark repair tools a year. "Someone needs to explain to a lot of players, especially beginners, these are the things you need to know to enjoy the game more and get more out of it," Dan explains. "I consider it a personal mission."

His course is short, tricky, inexpensive, fun to play, and takes golfers past some of the finest homes anywhere on Oregon linksland. As far as I know, it also is the first golf course in the world to ban smoking. "I got tired of picking up butts," Dan says.

Nine holes at the Highlands, combined with a good dinner at any of a number of outstanding restaurants to the south in Cannon Beach, constitutes as fine a golf getaway day as you can have.

Curiously, many Portland-area golfers insist that the quintessential getaway is only a fifteen-minute drive from the city. The claim is that few golf venues are the equal of Royal Oaks Country Club, always listed among the top one hundred classic courses in America. Yes, it is located in Vancouver, Washington, and not in Oregon, making it an unusual entry here, but this jewel was ignored for years by experts compiling "best in the state" lists on both sides of the Columbia River. Reviewers seemed confused over where Royal Oaks belonged, with those to the north in Seattle considering it a Portland-area course and Oregon evaluators quite accurately placing it in Washington. For the record, Royal Oaks is in the Evergreen State but is a member of the Oregon section of the PGA.

As early as 1940, Byron Nelson played an exhibition at Royal Oaks and declared the greens to be the best in the Northwest. A half-century later, when Tiger Woods came for the Pacific Northwest Amateur in 1993, the rising young star concluded that Royal Oaks' greens were of USGA tournament quality in speed and smoothness. Longtime members don't need to be told that all approach shots must be kept below the hole.

But more than just a collection of perfect putting surfaces, Royal Oaks is an exquisite park, with a variety of tall trees on every hole, brightly colored flower gardens throughout, flowing creeks, placid ponds, and exquisite grooming. For style, I would put it in the same category as Portland Golf Club, Eugene Country Club, or Waverley Country Club. It is, in a word, classic. Even more noteworthy for a Northwest course, it is flatter than a pro shop countertop.

"What makes the course great is the terrain," says Bobby Litton, one of the club's founders in 1945, and a touring pro before there was a PGA Tour. "When we looked for the land, terrain was our number-one deal. People might like the views on hilly courses, but after awhile, they get sick of walking them."

It's hard to imagine one could ever tire of walking this splendid course. Yes, it is private, which only adds to the appeal of the ultimate getaway. But get an invitation to play here and you will lose yourself in the serenity of true golfer's paradise.

Finally, the closest, fastest getaway from Portland. Edgefield Lodge in Troutdale, about twenty minutes east of the city and previous site of the old Multnomah County poor farm, has added perhaps the niftiest par-3 course in the state. It is the work of Portland's McMenamin brothers, who have made careers of converting historic buildings in the area into thriving breweries, eating establishments, and watering holes.

Play their little course—which requires demanding tee shots of fifty to seventy-five yards to fast, true greens—have a burger and a brew, and you're back in town in a couple of hours. With just a little more time, stay the night in the lodge, play again in the morning, and you're home before lunch.

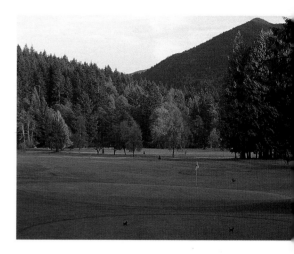

▲ *Scotland has highlands, too, and the Resort at the Mountain features its own Scots!*
▶ *The views at Central Oregon's Crosswater are always uplifting, especially when the golf game being played is not.*

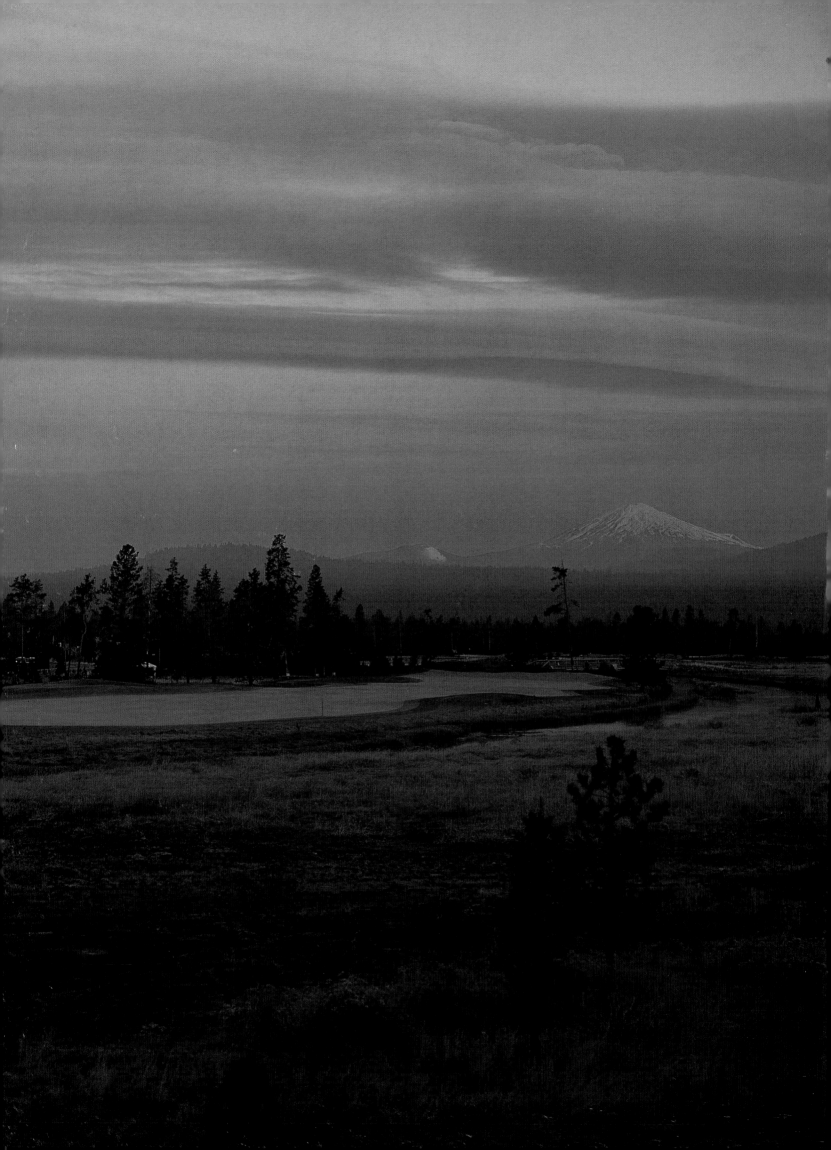

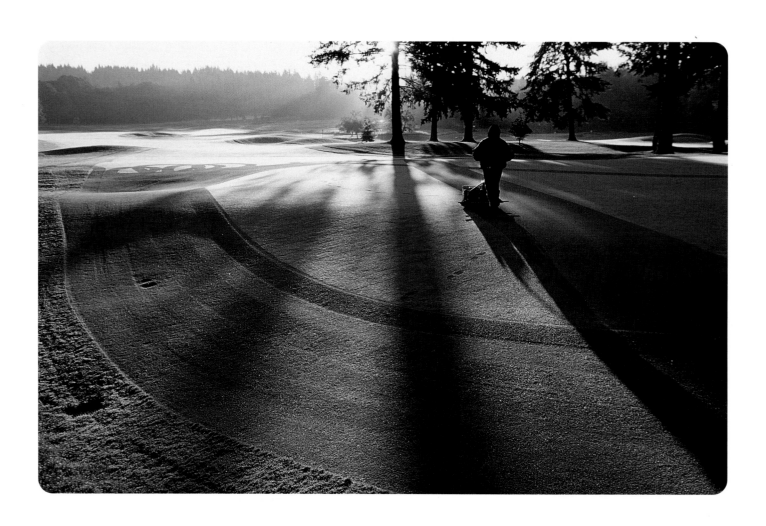